WRITING ABOUT

THIRD EDITION

D0981646

HENRY M. SAYRE
Oregon State University

PRENTICE HALL, Upper Saddle River, New Jersey 07458

Library of Congress Cataloging-in-Publication Data

Sayre, Henry M.
 Writing about art / Henry M. Sayre. — 3rd ed.
 p. cm.
 Includes bibliographical references and index.
 ISBN 0-13-959917-7
 1. Art criticism—Authorship. I. Title.
 N7476.S29 1999
 808'.0667—dc21 98-36137
 CIP

Editorial Director: Charlyce Jones-Owen
Publisher: Bud Therien
Assistant Editor: Marion Gottlieb
AVP, Director of Manufacturing and Production: Barbara Kittle
Managing Editor: Jan Stephan
Production Liason: Fran Russello
Project Manager: Publications Development Company of Texas
Prepress and Manufacturing Buyer: Bob Anderson
Cover Director: Jayne Conte
Cover Design: Bruce Kenselaar
Marketing Manager: Sheryl Adams
Front Cover: Robert Motherwell (1915–1991) American, "Calligraphic Open" 1974. Acrylic and charcoal on canvas H 231.1 cm W 365.8 cm D 0.0 cm. Founders Society Purchase, W. Hawkins Ferry Fund, the Maxwell and Marjorie Jospey Fund, and partial gift of the Dedalus Foundation. Photograph copyright 1995 The Detroit Institute of Arts. Acc No. 1995.28. Copyright Dedalus Foundation/Licensed by VAGA, New York, NY.
Back Cover: Pablo Picasso, Spanish, 1881–1973. "Woman With a Book", 1932. Oil on canvas 51⅜ × 38½". The Norton Simon Foundation, Pasadena, CA, Estate of Robert Ellis Simon, 1969. (Copyright) 1998 Estate of Pablo Picasso/Artists Rights Society (ARS), New York.

This book was set in 11/13 point Times Roman by Publications Development Company of Texas and was printed and bound by Courier Companies, Inc. The cover was printed by Phoenix Color Corp.

© 1999, 1995 by Prentice-Hall, Inc.
Upper Saddle River, New Jersey 07458

Printed in the United States of America

10 9 8 7 6 5 4 3

ISBN 0-13-959917-7

PRENTICE-HALL INTERNATIONAL (UK) LIMITED, *LONDON*
PRENTICE-HALL OF AUSTRALIA PTY. LIMITED, *SYDNEY*
PRENTICE-HALL CANADA INC., *TORONTO*
PRENTICE-HALL HISPANOAMERICANA, S.A., *MEXICO*
PRENTICE-HALL OF INDIA PRIVATE LIMITED, *NEW DELHI*
PRENTICE-HALL OF JAPAN, INC., *TOKYO*
PEARSON EDUCATION ASIA PTE. LTD., *SINGAPORE*
EDITORA PRENTICE-HALL DO BRASIL, LTDA.. *RIO DE JANEIRO*

CONTENTS

iii

3

RESPONDING TO THE VERBAL FRAME: Where Else to Look for Help in Understanding What You See 58

4

WORKING WITH WORDS AND IMAGES: The Process of Writing about What You See 88

Appendix

A SHORT GUIDE TO USAGE AND STYLE: The Rules and Principles Most Often Violated in Writing about Art 115

ACKNOWLEDGMENTS

This book was begun, as an idea at least, many years ago, when as a graduate student in American literature at the University of Washington in Seattle, I taught freshman composition under the direction of William F. Irmscher, author of the famous *Holt Guide*. I hope something of the pleasure he took in teaching us to teach composition comes through in these pages.

It was Kevin Johnson, at Prentice Hall, who first suggested that I undertake this project, and I thank him for his idea and for his continued support. My editors at Prentice Hall, particularly Marion Gottlieb and Norwell "Bud" Therien, make all of this fun to do, and Mary Amoon, an editorial assistant who I am beginning to believe can magically save any situation, deserves my special thanks.

Finally, as always, I want to say how much I appreciate the many students who have used this book and suggested ways it might be better. Again, this book is for you.

PREFACE

As a teacher of undergraduate courses in art appreciation and art history, I have always felt that one of the most important activities students engage in is *writing*. It is my conviction that the better, and the sooner, students write about what they see, the better they will see. To write about art is to engage in the best process I know for organizing—even recognizing—your thoughts and feelings about the visual world.

This book is addressed to you, the student of art. I hope that it will help you to write about art more effectively and thus teach you, through the process of writing, how to see works of art in more meaningful and lasting terms. Many of you are already effective writers, many of you may still lack the confidence you need to feel that you write well.

If you are reading this book, you almost surely find the problem of writing about art a vexing one. If the visual arts expressed the same things in the same way as the verbal arts, then why would anyone bother to paint or sculpt or take photographs in the first place? Most people feel that images tend to "say" things that words can't. For them, being asked to write about art is like being asked to express the inexpressible.

Without denying the uniqueness of the visual experience, let me suggest that works of art are a form of address, directed at you, their audience. Like most forms of address, they demand a response. To write about a work of art is to respond in what for most of us is the most readily available means. To demonstrate the kinds of response a work of art might generate, I have written, in this book, about works of art that have excited me—and continue to excite me—and I have also included several responses to works of art written by my students. These essays were generated in my classes and, if they are not always the "best" imaginable response to a given assignment, they represent an effort on my part to choose the kind of writing that you can learn from best. For that reason as well, I have not used passages from renowned critics or historians to illustrate writing techniques. I have nothing against aspiring writers attempting to imitate the best practicing critics and historians, but imitation is difficult for many students and not, I believe, the most effective way to teach writing. The business of a book such as this is to build

confidence, to give you a foundation upon which you can improve. Judging from the overwhelmingly positive student response to this book, I can't help but think that good student writing is a more useful model than the stylistic subtleties of professionally wrought prose.

For this, the third edition of *Writing about Art,* I have made one very important change. Since the publication of the first edition of this book in 1989, the word processor has virtually usurped the place of the typewriter in writing, and the computer, CD-ROM, and database have transformed the possibilities of research. As recently as 1993, the World Wide Web was still something of a dream. When the second edition of this book was published in 1995, I began my discussion on research methods as follows: "First, go to the card catalogue. It may or may not be an actual "catalogue"—libraries are rapidly converting their catalogues to database formats, accessible at computer stations." Today, there may still be a few libraries that are not "on-line," but I don't know where they are. Though I sometimes think that the technology is changing as rapidly as I can write a sentence, in this edition I have tried to address the needs of the student writer working at every level of technological sophistication, from pen and paper (still the technology of choice in an exam situation), to typewriter, to word processor. I have also tried to give some idea of the research resources available in the exploding world of the information network, particularly on the World Wide Web.

Finally, let me say that I hope this book convinces you that writing about art is a rewarding and pleasurable experience, an act of exploration and discovery in some ways comparable to the creative act itself. At the very least, this book should help you to write better papers in your art appreciation and art history courses. In the end, I hope the book increases your confidence—and joy—in the process of writing itself.

HENRY SAYRE

ILLUSTRATIONS

INTRODUCTION
The Process of Seeing and Writing

For many years, before beginning to teach art appreciation and art history, I taught literature and composition at the university level. During those years, I heard a lot of creative excuses for poorly written essays, but it wasn't until I began teaching art that I heard students claim that their weak writing was attributable to their being "right-brained," as if, as artists, they were biologically incapable of writing well. The excuse probably owed much of its currency to the famous drawing book by Betty Edwards, *Drawing on the Right Side of the Brain,* a book that was, in the early 1980s, extraordinarily popular.[1] Edwards wrote the book with the best of intentions. She wanted to help people who believed they had no artistic talent learn to draw, and she wanted to demonstrate, further, that there were ways in which people learn—namely visual—that traditional approaches to education by and large ignored, to the detriment of many very capable students. Scientists had long understood that injury to the left side of the brain could severely impair verbal ability. Edwards's book focused on more recent research demonstrating that the right side of the brain showed little or no concern for matters of logic and language but was, rather, the repository of intuition, dreams, and images. The right side of the brain was, thus, the artist's domain, and it became fashionable, especially among certain art students, to cultivate a "right-brained" persona. It became an integral part of their definition of

themselves as artists. Artists, so the argument went, think differently than the rest of us. They are removed from the world of logic and words. We of the left-brained populace should be content to let them drift in their sea of unbounded associations and free-floating images. To Edwards's credit, she argued strongly that if half a brain is better than none, then a whole brain is better than half. She believed that artists should develop the left side of their brains, their verbal skills, just as the rest of us should develop our artistic side. Still, the "right-sided" persona has persisted, and with it the myth that artists don't talk, let alone write. Artists make art.

Of all modern painters, probably Jackson Pollock did more to promote this idea of the nonverbal artist than anyone. And, on first view, his work seems almost certain to promote verbal incapacity in its audience as well. (Art students are not the only ones who have trouble writing about work such as Pollock's. Even seasoned critics have been known to be struck mute before his large abstractions.) Pollock so disliked language, at least as it related to his painting, that as often as not he refused to title his work, assigning each a number instead (Fig. 1).

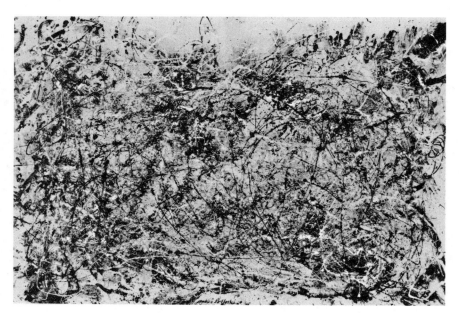

Figure 1 Jackson Pollock, *Number 1, 1948,* 1948. Oil and enamel on canvas, 68 in. × 8 ft. 8 in. The Museum of Modern Art, New York. Purchase. © 1998 Pollock-Krasner Foundation/Artists Rights Society (ARS), New York. Photograph © 1998 The Museum of Modern Art, New York.

Early in his career Pollock had so frustrated his psychiatrist with his nonverbal behavior that his therapy was in jeopardy. Communication between the two became possible only when Pollock revealed that he was, more or less routinely, illustrating his psychic condition in his notebooks. His psychiatrist was finally able to talk to Pollock upon seeing his drawings. That is, he was able to convert the images into words, to translate the nonverbal into the verbal, and thus move Pollock's therapy forward.

If Pollock was unwilling to talk even to his psychiatrist, whom he claimed to trust, he was even less willing to speak in public. Only when he drank—and his reputation as a man of the bottle was unmatched in New York in the early 1950s—did he talk in public, and then often only to let loose with such a string of obscenities that most of his colleagues at the famous Cedar Bar, the artists' hangout he frequented, greatly preferred his silence. He soon developed a reputation as, alternately, a great, hulking, hugely talented mute and a loud, pushy, famously abusive drunkard.

There was, however, at least as much shadow as substance to Pollock's quietude. "It's a myth that he wasn't verbal," his wife, the painter Lee Krasner, said in an interview in 1967, a decade after he died in a car accident near his home on Long Island. "He could be hideously verbal when he wanted to be. . . . He was lucid, intelligent; it was simply that he didn't want to talk art. If he was quiet, it was because he didn't believe in talking, he believed in *doing*."[2] There is probably no better explanation of the "meaning" of the many untitled and numbered paintings in the body of Pollock's work. His refusal to title or discuss his paintings *tells* us something about them—that we are to see in them, as a record of Pollock's *"doing,"* the activity of making art itself. As a matter of fact, we can detect in Pollock's conscious refusal to put words to his images a choice that takes on a particularly American tone, for born and raised in the West he always conceived of himself as something of a rough, tough cowboy, the silent hero who rides into town, takes care of business, and rides out again. He was the art world's Clint Eastwood.

Even when one is confronted by a work of art that is so obscure it seems impenetrable, one that looks as hopelessly confusing or willfully pointless as a Jackson Pollock must appear to the untrained observer, a certain fabric of choices and decisions is nevertheless always apparent. The process of writing about art depends upon the recognition of these choices and decisions. For Pollock to paint as he did, he had to *choose* not to paint in a traditionally representational way, suppressing or rejecting traditional subject matter. He had to *choose* to pour paint on canvas

lying on the floor instead of resting on an easel. He had to *choose* to paint on very large surfaces instead of small ones, to create a design of scribbles and curves and arabesques as opposed to a grid of straight lines and geometric shapes, to title his paintings or not.

The process of writing about art, then, begins with recognizing that certain decisions have been made and wondering why. When you write about art, begin by identifying some of these choices, and then proceed to the problem of determining *why* an artist made the choices he or she did. Chapter 1, "Choosing Images," is about how to put yourself in the best position to recognize these decisions. Viewing a work of art and writing about it involves, of course, some initial decision making on your own part. You have to ask yourself, "Among all the possible images for me to write about in the museum or gallery, or in a book, which is the work of art I can write about most effectively?" Then, having made an intelligent choice of your own, you can begin to determine what meaningful choices the artist has made.

Chapter 2, "Using Visual Information," is a summary of the visual elements from which an artist might choose. The intention of the chapter is to help you recognize what sorts of visual information might be important for you to write about, but if you find you need more help or further elaboration, you should consult one of the many discussions of the visual elements that are widely available in art appreciation texts, including my own *A World of Art*.

In Chapter 3, "Responding to the Verbal Frame," the problem of words and their relation to the image is addressed. All images are surrounded by words—in their titles, in accompanying exhibition materials, in critical and art historical discussions. Some works of art even contain words. It is, of course, not always necessary to consider all the verbal baggage an art work carries with it. Depending upon the nature of the essay you have to write, you may or may not want to consult secondary sources such as critical commentaries or monographs for help in understanding the image. Some of this verbal material, however, is essential, and, in one way or another, it all can help you begin to think about your own verbal approach to the work of art.

Chapter 4, "Working with Words and Images," is about the crucial activity of writing itself. One of the first things you will discover, if you don't already know it, is that there is a slippage or gap between the image and its meaning. Take, for instance, Carrie Mae Weems's photograph of a common coffee pot (Fig. 2). Visually, it's just a coffee pot, or more precisely, a photograph entitled *Coffee Pot*. That said, already, we've slipped away from the object itself, since this coffee pot has been acted

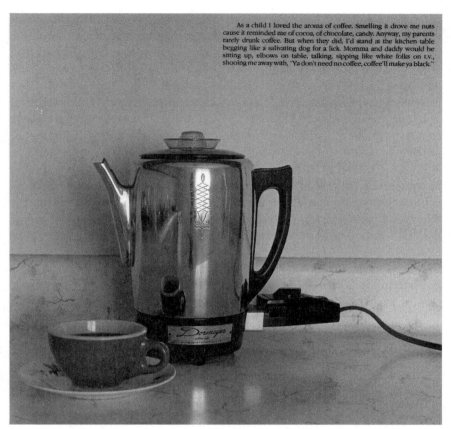

As a child I loved the aroma of coffee. Smelling it drove me nuts cause it reminded me of cocoa, of chocolate, candy. Anyway, my parents rarely drunk coffee. But when they did, I'd stand at the kitchen table begging like a salivating dog for a lick. Momma and daddy would be sitting up, elbows on table, talking, sipping like white folks on t.v., shooing me away with, "Ya don't need no coffee, coffee'll make ya black."

Figure 2 Carrie Mae Weems, *Coffee Pot,* 1988. Courtesy P.P.O.W., Inc. New York.

upon, photographed, selected, "posed," if you will, arranged, framed, lit, and most of all, assimilated into the world of Carrie Mae Weems, a world much more fully defined by the text that accompanies it.

Weems's image/texts are strategies of opposition. Her parents, in *Coffee Pot,* are "sipping like white folks on t.v." Drinking coffee makes them look white to their daughter, and yet they warn her that drinking coffee will "make you black." The seemingly "straight" photography, which seems merely to document the way things are, is juxtaposed to Weems's first-person narration, which possesses its own authority of an authentic voice, a voice that tells us what this coffee pot means to Weems. If the photograph attests that the coffee pot is, or was at one time, real, Weems's narration describes its greater reality. As we move from image to text, from one sense to another, that is, from the sight of

the coffee pot to its aroma, we move from the "truth" of photography to the fiction of Weems's story, from the language of black-and-white photography to the realities of being black and white in America.

Weems's narrative seems to open up the image to the possibilities of meaning, but especially in the first stages of writing, your own attempts to put words to images will often seem *reductive*. While whatever you have to say might well be true, you will likely feel that it is true only to a degree. Most images are more ambiguous than you will at first be willing to admit. You will want to pin the image down, understand it, and you will tend to think that understanding is itself unambiguous. But if you agree that one of the primary reasons to write about art is to *interpret* the meaning of the images it presents, and if you reflect on the word *interpretation* for a moment, you can see that almost by definition a work's meaning is never single; it is always open to discussion, even heated debate. Thus, Frederic Edwin Church's monumental painting of a South American volcano in eruption, *Cotopaxi, Ecuador* (Fig. 26), painted in 1862, has sometimes been read as an awe-inspiring transcription of the sublime power of the natural world, as an expression of the Divine in nature, following the lead of Ralph Waldo Emerson's transcendental philosophic thinking, and as an allegory of the American Civil War in which the beleaguered forces of the North can still be seen shining through the smoke produced by the furious and volcanic onslaught of the South. Finally, in more psychological terms, the painting can be seen as symbolic of sexual conflict and union. Perhaps all of these readings contribute to the power of the painting, which was indeed one of the most popular of its day.

I mean to suggest that images are generally "open" to a variety of readings and interpretations. Some interpretations, such as the "sexual" reading of *Cotopaxi,* might be difficult to justify, and without careful explanation, may seem arbitrary, even absurd. But great works of art can sustain almost as many readings as there are viewers. This is the point of a series of paintings by Robert Motherwell begun in 1967. Motherwell had prepared a large vertical canvas by painting the entire surface yellow ochre. He left it for a while, leaning another small painting against it as he worked on other things. But the relationship of the small painting to the large yellow ochre ground attracted him, and he outlined the small painting in charcoal on the yellow ground. After a while he decided he liked the relationship upside down better than right side up, and so he reversed the work, allowing the smaller rectangle to descend from the top. He quickly made several more paintings along the same lines, and named them all with the word *Open,* one of which is reproduced on

the front cover of this book. The image not only suggests an open win-
dow, hanging from the top of the painting, but also an openness to the
possibilities of painting. As the broad, uniformly painted ochre field of
the canvas opens to the more agitated brushwork of the interior square,
so the unformed brushwork gives way to the linear black mark of another
"open" form within. This mark has a calligraphic quality that suggests
writing, as if it were a sort of undecipherable written sign. "In the Ran-
dom House unabridged dictionary," Motherwell explained, "there are
eighty-two entries under the word 'open' that could be set on separate
lines, as in a poem. For me those entries are most beautiful, filled with
all kinds of associations, all kinds of images."[3] Among the lines in
Motherwell's "poem" are the following:

—not closed or barred;
—having the interior immediately accessible;
—having relatively large or numerous voids;
—perforated or porous;
—accessible or available;
—free from frost;
—undecided; unsettled;
—unreserved, candid, or frank;
—(of a seaport) available for foreign trade;
—(of a female animal) not pregnant;
—to expand, unfold, or spread out;
—to clear;
—to admit passage;
—to make an incision;
—to place the first bet;
—to begin a session, season, or exhibition;
—to be publically known or recognized, out in the open;
—unenclosed or unobstructed country;
—in the out-of-doors, in the open air;
—on open water

Now, there may be better poems, especially rhythmically speaking, but
this poem about "open"—all adjectives, verbs, and nouns of it—makes
clear a point generally lost when we speak of the relation of words and
images, and more specifically, the function of titling. Words don't de-
limit the meaning of an image—or need not. They can explode meaning,
as we find ourselves, in the case of Motherwell's paintings, adrift on the
openness of *Open.*

Writing about works of art always involves walking the line be-
tween the image's openness, or its susceptibility to interpretation, and

its integrity, or its resistance to arbitrary and capricious readings. We must continually test our reading of a work of art against the image itself. We must determine if it is complete enough (if it recognizes the full range of possible meanings the work might possess) and, at *the same time,* we must ask ourselves if our reading violates the image, misrepresents it.

Writing about Art is meant to help you learn to test your interpretations of works of art through the process of writing about them. And it is meant to help you become a better student, not just because you will get better grades for better written essays, but because in learning to test your interpretations of works of art through the process of writing about them, you will learn to *think* better as well. You will learn to think with your whole brain. Today, when I give a low grade for a bad essay, I hear the "right-brained" excuse less frequently than I used to. Many art students—students generally—today simply take their bad writing for granted. They shrug it off and admit they don't write very well. But they are almost always willing to learn to write better because they know it matters. If the art department is where the university seems to have channeled the verbally disinclined, students of art are no longer the only ones having difficulty expressing themselves adequately as writers. Today, more than ever before, I hear from history majors, anthropology majors, literature majors, and above all art history majors—writers all—that they haven't written the paper they know they are capable of producing. This book is really for both groups—for the nonverbal student and for the highly verbal writer—both faced with the same, sometimes daunting task of finding words for images, and then writing about images well. Our culture is increasingly dominated by images, and all students today must learn to see and interpret the visual world around them.

Writing about works of art will, finally, teach you one of the most important of all critical habits—that is, it will teach you to question what you see. Most professors are not nearly so interested in your discovering the "right" interpretation of a work of art—they recognize a certain "openness" and amplitude in the work—as they are in seeing you ask hard questions about the work itself and about your responses to it. My primary goal as an educator—and I share this goal with many others—is to teach you to be actively engaged in your world, not passively receptive to it, to be at once critical and self-critical. Writing about art is one way to begin this larger process. The skills you develop will be, I promise, applicable to whatever endeavor you choose to pursue in your life.

1

CHOOSING IMAGES

How to Select the Works of Art
You Plan to Write About

Unless your professor assigns specific works of art for you to write about, one of the most difficult tasks you face is selecting an appropriate subject, one that is accessible and manageable, and yet challenging enough to provoke interesting thought and writing. This chapter is designed to help you choose an appropriate topic from the outset. One of the first things you need to take into consideration is the context in which you approach the work.

VISITING MUSEUMS AND GALLERIES

When you enter a museum, how do you feel, and do your feelings affect the way you see? This is not so much to ask whether you feel happy or sad, bored or confused—though your mood and temperament can obviously affect your perception of things—but whether the museum itself reminds you of a church or a library, a lecture hall or a department store. In the late 1960s two French scholars surveyed a cross section of the French population and discovered that 66 percent of all manual workers, 45 percent of all skilled and blue-collar workers, and 30.5 percent of the professionals and upper-level managers most closely associated museums with

churches. A large group of the skilled and white-collar workers—34 percent—felt that the museum was most analogous to the library. Of the professionals and managers, 28 percent likened the museum to the library. Only small percentages of each group felt that they were like lecture halls or department stores. But a large number of professionals, nearly 20 percent, felt that a museum was like none of these other institutions. A museum, they must have felt, is most like itself.[1]

These figures can be interpreted in any number of useful and interesting ways, but my point is a simple one: For most people, the museum possesses an aura, a mystique, that literally transforms the work of art. The museum removes art from the context of everyday life. Everywhere there are signs—"Please Do Not Touch the Works of Art"—that imply to many people not only the "purity" and "sanctity" of art itself, but by extension their own relative corruption. Like the library, the museum also demands their *silent* contemplation and study of its objects. It is the kind of space in which people feel compelled to whisper, reverently, and in which parents feel obliged to collar their children, put them on their best behavior, and demand their submissive attention.

People tend to take museums rather seriously—perhaps too seriously. Marcel Duchamp, in one of the most important gestures in the history of twentieth-century art, pointed this fact out when he purchased a common urinal at an ordinary plumbing store, signed it with the pseudonym R. Mutt, entitled it *Fountain,* and submitted it to the 1917 Independents Exhibition in New York City (Fig. 3). The urinal was

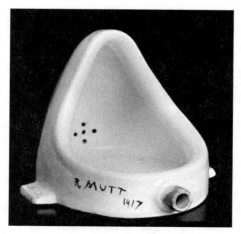

Figure 3 Marcel Duchamp, *Fountain,* 1917.
Selected object, 24 in. high. Photograph
courtesy Sidney Janis Gallery, New York.

at first rejected by the jury, which no doubt considered it simultaneously obscene, ludicrous, and banal, but when it became known that "R. Mutt" was in fact none other than Marcel Duchamp, the piece was quickly installed in the show, behind a partition. Soon critics waxed on about its purity of line and the graceful symmetry of its structure. In the spirit of the piece, one poet would write, "Would not life be lovelier if you were constantly overjoyed by the sublimely pure concavity of your wash bowls? the tubular dynamics of your cigarette?"[2] Wouldn't it be nice, in other words, if we approached all things in life with the attentiveness we habitually give to works of art? Wouldn't it be nice if we saw the world *aesthetically?*

Duchamp's point was that in order to see aesthetically, most of us—those who aren't poets or artists—need to be prodded, and what jogs our aesthetic sense most readily is the museum itself. When we enter its doors, we somehow agree to see differently. A urinal, for instance, might lose its functional purpose; we might even approach it as sculpture. Context, in short, plays a large role in determining the way we see. And the power of Duchamp's piece lies in the fact that it forces us to recognize that the aesthetic dimension of a thing might be more a function of where we see it than of any quality inherent in the thing itself.

In the same manner, the walls, the frames that surround works of art, and other works in a given gallery space influence the ways in which we see works of art. In 1991, the Museum of Fine Arts, Boston, invited Louise Lawler, a photographer who specializes in drawing our attention to the way art is displayed, to install an exhibition of her own work and whatever other work in the Museum she might wish to use. Entitled "The Enlargement of Attention," the exhibition demonstrated how the museum itself manipulates the way we see. In one room (Fig. 4), for instance, Lawler hung a large Roy Lichtenstein painting of the pyramids

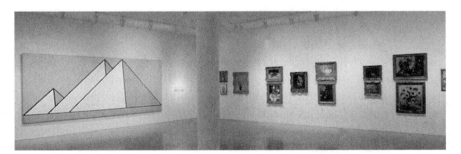

Figure 4 Louise Lawler, installation view showing Roy Lichtenstein's *Three Pyramids,* 1969, and 13 still-life paintings from the Spaulding bequest, "The Enlargement of Attention," Museum of Fine Arts, Boston, 1991. Courtesy the artist and Metro Pictures.

at Giza next to thirteen small still-life paintings of tabletop flower arrangements donated to the museum by one John Taylor Spaulding. Lichtenstein's painting, framed by a simple wooden strip, dominates the room with its comic strip depiction of the last surviving example of the original Seven Wonders of the World. It dwarfs the still-lifes, and suggests they are not as important as it is, or at least that Lichtenstein's brand of painting has usurped and superseded the "old-fashioned" art of painting still-lifes in oil, to say nothing of the tradition of displaying such works in ornate, gilded frames. Lawler has hung a small sign by the still-lifes, explaining that they were "gathered together from storage or office areas for this installation," thus reinforcing their "secondary" status. But the viewer is drawn to the smaller works, in part because they are not as immediately accessible to the eye as the Lichtenstein. Looking at them, the Lichtenstein looming over the viewer's shoulder like a giant ogre, one thing becomes clear. The museum normally hides such discontinuities in its collections, organizing its galleries into coherent displays that reflect inward upon themselves rather than outward upon each other. Lawler reveals the hidden incoherence of the museum as a whole.

A related example is the so-called "white room" effect that dominates the display of contemporary art. Contemporary paintings such as Lichtenstein's are painted with just such an environment in mind; it is assumed that they will end up surrounded by a more or less pure, immaculate, and virgin space. Though a medieval or Renaissance crucifixion might have been painted with an entirely different site in mind for the work—perhaps a cathedral or chapel—the effect is not very different. In the church, particularly in the cathedral, there might be other sources of visual interest—sculpture, stained glass, the very architecture of the place—but it is the centrality of the crucifixion to the Christian tradition, the power of the image itself, that draws our attention to it. Both the church and the white room create an atmosphere of *attention,* one could even say *devotion.*

The presence of the thirteen still-lifes in Lawler's installation distracts us. They violate the white room effect. In the white room, nothing should distract the gaze from the work, in the way that the still-lifes seem to divert our attention from the monumental Lichtenstein. One of the best analyses of this situation can be found in a series of essays by Brian O'Doherty, originally written for *Artforum* in the mid-1970s, entitled "Inside the White Cube." As O'Doherty says,

> The ideal gallery . . . subtracts from the artwork all the cues that interfere with the fact that it is "art." The work is isolated from everything

that would detract from [it]. . . . The outside world must not come in, so windows are usually sealed off. Walls are painted white. The wooden floor is polished so that you click along clinically or carpeted so that you pad soundlessly, resting the feet while the eyes have at the wall. The art is free, as the saying used to go, "to take on its own life."[3]

The art is anything but free, however, and this ambiguity, which is perhaps inevitable, repeats itself in various forms throughout our experience of it. For although the work of art is technically isolated from things that would interfere with our appreciation of it for its own sake and in its own terms, it perpetually encounters a force "from the outside," one might say, a force that is always violating its sanctity. It is always meeting the enemy face to face—and the enemy is us.

We all carry all manner of baggage with us when we see works of art, even if it is downright distaste for the particular work of art we happen to be looking at, and what we carry affects what we see, let alone how well we see it. Seeing art, then, as much as it is a critical operation, is a self-critical one as well. It involves, absolutely, examining our own prejudices and preconceptions. If the work of art seems distant from us, isolated there on the wall, that is so because, in a certain sense, it needs that protection. Museum histories are rife with examples of the mutilation of works of art. But the work of art needs also to rise above whatever ignorance or misunderstanding we might initially bring to it, even if we aren't about to abuse it physically. It needs to demand our respect. The history of modern art is in some ways the history of the public's misapprehension and disapprobation of art it would eventually come to admire and love. Almost everyone today likes Impressionist painting. Yet when it first appeared in France in the 1870s, it was thought laughable, even scandalous. In his 1886 novel, *The Masterpiece,* Emile Zola provides a fictionalized account of the crowd's reaction to an Impressionist painting that more or less summarizes the way in which much of the work of his friends and contemporaries—Manet, Cézanne, Monet, Sisley—was initially received:

> It was one long-drawn-out explosion of laughter, rising in intensity to hysteria. As soon as they reached the doorway, he saw visitors' faces expand into anticipated mirth, their eyes narrow, their mouths broaden into a grin, and from every side came tempestuous puffings and blowings from fat men, rusty, grating whimperings from thin ones, and, dominating all the rest, high-pitched, fluty giggles from the women. A group of young men on the opposite side of the room were writhing as if their ribs were being tickled. One woman had collapsed on to a bench, her

knees pressed tightly together, gasping, struggling to regain her breath behind her handkerchief. . . . The ones who did not laugh lost their tempers, taking the overall blueness [of the picture], Claude's original way of rendering the effect of daylight, as an insult to their intelligence. It was an outrage and should be stopped, according to elderly gentlemen who brandished their walking sticks in indignation. One very serious individual, as he stalked away in anger, was heard announcing to his wife that he had no use for bad jokes. . . . It was beginning to look like a riot. More and more people kept forcing their way up to the picture, and as the heat grew more intense faces grew more and more purple.[4]

Context is playing a large part in determining the reaction of this crowd. The picture they are outraged by describes nature—the effects of daylight—in what is, to them, a new way. It is unlike anything else in their experience. And it is unlike anything else around it. It is hanging, furthermore, in what was known as the Salon des Refusés, an exhibition of all the works that were submitted to the main Salon but refused acceptance by the French Academy. It is, from the point of view of the crowd, the most scandalously bad painting in an exhibition of officially bad paintings.

It is perhaps fair to say that one reason we have so little trouble ourselves in seeing paintings such as the one described by Zola as works of great beauty, rather than as objects of derision, is that we are used to seeing a great many of them, together, in the large gallery devoted to Impressionist painting in the Metropolitan Museum, for instance, or on the top floor of the Musée d'Orsay in Paris. Here, seen as a group, the paintings tend to inform one another. We can see for ourselves, in a series of Monet haystacks, how at different times of day, in different seasons of the year, and in different weather, the same scene can dramatically alter in effect. Or we can witness the logical growth of Cézanne's ideas about composition if we compare an early rendering of a particular motif, such as his *Mont Sainte-Victoire* of 1885-87 (Fig. 20), discussed in Chapter 2, with a later version of the same scene (Fig. 21).

One of the primary functions of museums is to provide just this sort of educational experience, to allow us to see *in context* works of art that in isolation might appear extravagant or ill-considered or even badly executed. (And, on the other hand, they avoid grouping works together which apparently have nothing in common, as Lawler has done in her installation.) In commercial galleries, which after all are in the business of selling the works of art they display, the sense of unity and coherence that Lawler defies is most readily apparent. The so-called "one-person" show, the staple of the gallery system, almost guarantees

a coherent visual effect, and galleries themselves are often known by the particular "look" or style that they champion. A sense of unity can be achieved in any number of ways, however, particularly in the larger context of the museum, where collections are sometimes wildly various and the potential for chaos is markedly greater. Commonly, in museums, works of art are grouped by school or group (the Cubists, for instance, in one room, the Futurists in the next), by theme (landscapes or portraits), by nationality and/or historical period (nineteenth-century British painting or seventeenth-century Dutch), by some critical theory, or by some combination of these ("Nineteenth-Century British Landscape," for instance, or "American Abstraction: Its Roots and Legacy").

Curators also often guarantee the continued movement of people through the museum by limiting the number of important or "star" works in any given space. The attention of the visitor is drawn to such works most often by positioning and lighting, as our attention is drawn to the Lichtenstein in Lawler's installation. When a particularly large painting such as Lichtenstein's occupies a wall, the other works in the room will almost always be smaller, and might even be drawings or sketches. A relatively small but important painting might be sumptuously framed, or hung by itself on a wall, perhaps accompanied by especially elaborate explanatory material.

The museum, in other words, is addressed to *you*. It wants to make art available to you, and it wants you to gather, from your experience, a greater understanding of and appreciation for what you've seen. Although the work of art, and the museum itself, might possess a certain aura of religiosity or sanctity, if we grant the art the respect that is its due, we are free to enter into a dialogue with it, for, like the museum as a whole, each individual work is addressed to its audience, individually and collectively. If you do not allow yourself to be intimidated by the museum, and if you recognize the ways in which your own responses are being manipulated—sometimes to great advantage—by the museum itself, this dialogue can be particularly interesting and worthwhile.

CHOOSING WORKS OF ART TO WRITE ABOUT: SOME QUESTIONS OF TASTE

One of the best ways to think of the task before you when you are asked to write about art is to approach it as a kind of dialogue between you and the work. It is your business, when you write about art, to record

this dialogue. But there are dialogues and dialogues. You want to avoid having your dialogue turn into a diatribe. Therefore, the first rule of thumb is to avoid, if at all possible, writing about something you simply don't like or don't understand (often these are the same thing).

All too often, when we are confronted by things we do not understand, we react to them in the way that Zola's crowd reacted to the painting in *The Masterpiece*. We are all interested in reading why an authoritative critic dislikes a given work, but we risk appearing uninformed, even boorish, when we criticize what we don't understand. I have received, for instance, many a paper that pointed out how Manet or Picasso is a "bad" painter because, the argument goes, both "obviously" don't understand the laws of perspective. Of course, they *do* understand the laws of perspective but have chosen to violate those laws in order, among other things, to assert their independence from both traditional painting itself and conventional attitudes about the representational functions of painting. Such papers show not only that the writers are themselves traditional and conventional (not in itself particularly damning), but, more important, that they don't understand the paintings they are writing about.

You are entitled to your opinion. However, you should recognize the limitations of your opinion, and you should also recognize that in all likelihood your audience—namely your professor—is probably better informed on the subject than you are. This is not to say that you have to force yourself somehow to like all or even any of the works in a museum or gallery or in your text. It is, however, important that you recognize that someone thinks enough of them to have selected them and you need to respect their choice. It is your business not only to enter into a dialogue with the work of art, but to have a *respectful* dialogue, one that tries to account for the presence of the work in the museum itself. In other words, it is a good tactic to neutralize, as much as possible, your own opinions and to account instead for the opinions of others. Say to yourself, "Someone likes this. Why? What's interesting about it?" Quite often you'll find that in accounting for the interest of others, you will become interested yourself.

Sometimes you might find yourself able to write about a work that you're sure you understand completely. For instance, I often give beginning students the opportunity to visit any gallery they choose and to write about any work they want. A great many gravitate toward landscapes that remind them of home or—the example is admittedly trite, but it is an actual one—a still life of daisies named "First Love." The problem is that such works are often so accessible and so rudimentary in

their appeal, that once you've said, "It reminds me of home," or "It reminds me of my boyfriend, who is always buying me flowers," there isn't much left to say. It's certainly not wrong to like images of this kind, but it is important to recognize that, whatever their emotional appeal, they often lack the kind of intellectual richness that other kinds of art possess. Their attraction, furthermore, might be purely personal and may be of little or no interest to anyone but you. At the very least, recognize that there may not be sufficient complexity in them to sustain an interesting essay.

All this implies that the best works of art to write about usually possess a reasonable *complexity,* that they *challenge* you intellectually, and that they sustain a high level of *interest* on a plane other than the purely personal. In my own writing, I have usually found that the best pieces I have done have resulted not from my attempt to explain what I already know to an "unknowing" audience, but from my attempts to engage a work that I find in some way powerful even as I am unable, at first, to articulate just what the sources of that power might be. Writing then becomes a kind of exploration. This leads in turn to better writing, because the sense of mystery, excitement, and discovery involved in the process of exploration is never lost.

WRITING COMPARATIVE ESSAYS: SOME ADVANTAGES

Comparative essays are the staple of good art writing. Rather than writing about one work, it is often beneficial to write about several, since, in the process of comparing one work to another *related* work—and the two parts of a comparison should be related in some meaningful way—new ideas and perceptions about the work in question generally reveal themselves to the writer. Even if you are concentrating on a single work, comparing it to another can often shed light on a particular quality or effect that would otherwise be difficult to define or clarify.

Consider Charles Sheeler's *Bucks County Barn* (Fig. 5), painted in 1918 when Sheeler was living in a Quaker house built in 1768 at the edge of Doylestown, Bucks County, Pennsylvania. It is generally assumed that this painting was executed under the influence of the new modern styles of art, particularly the Cubism of painters like Pablo Picasso and Georges Braque, and many interesting comparisons can be drawn between Sheeler's painting and Cubist work. By outlining the similarities between the two, one can begin to assess the impact of

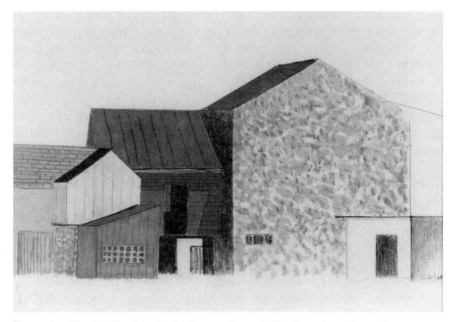

Figure 5 Charles Sheeler, *Bucks County Barn,* 1918. Gouache and conté crayon on paper, 16⅛ × 22⅛ in. Columbus Museum of Art, Ohio. Gift of Ferdinand Howald.

French Cubism on American art. Like the Cubist painter, Sheeler delineates the object in its most reduced form, relies on the differentiation of materials and surface textures for his visual effects, and emphasizes the two-dimensional surface of his canvas, flattening the scene in order to avoid creating an illusional three-dimensional space.

That said, there is something altogether American about Sheeler's work, something that exists outside the vocabulary of Cubist painting. In Milton W. Brown's classical account, outlined in his *American Painting: From the Armory Show to the Depression,* the "Americanness" of Sheeler's style is attributable to the vocabulary of "machine production and mechanical precision" that was so much a part of the American industrial age.[5] But consider a detail from a painting of another Bucks County barn, *The Cornell Farm* painted by the untrained American artist Edward Hicks in 1848 (Fig. 6). As in Sheeler's work, Hicks's painting emphasizes structural simplicity, textural surface, and especially two-dimensionality, though this latter is probably, in Hicks's work, more a matter of unskilled perspectival rendering than a question of intentional flattening. Since Sheeler was, in 1918, living in the same region that Hicks had originally painted, and since he was, furthermore,

Figure 6 Edward Hicks, *The Cornell Farm* (detail), 1848. Oil on canvas. National Gallery of Art, Washington. Gift of Edgar William and Bernice Chrysler Garbisch. © 1998 Board of Trustees, National Gallery of Art.

deeply committed to collecting antiques and artifacts, particularly of Shaker origin, from the region, it is possible to see *Bucks County Barn* not so much as the expression of the new modern styles of painting such as Cubism but as evidence that those styles had been anticipated in the native expressions of American art. It is as if Edward Hicks, the quintessential native-born and self-taught American painter, was, in 1848, a proto-Cubist. It is, in fact, possible to argue that Sheeler's work is not so much influenced by Cubism as it is willing to grant the validity of Cubism's way of seeing. The example of Hicks in a sense authorizes Sheeler's later Cubist idiom.[6]

It should be obvious this understanding of the "Americanness" of Sheeler's painting results from comparing it to Hicks's earlier work. Comparative essays are the basis of art history because, in fact, it is through the comparative essay that art history is constructed. If we think, for a moment, about why the discipline should be so dependent on the form, the comparative essay's usefulness should become much clearer to you.

How, we begin by asking, do art historians understand the development of a single painter? They look at early work by that painter and compare it to later works. They see, from one work to the next, a

development, or a progress. They can see in the later work its roots in the earlier work. They see things in the earlier work that assume an importance they might otherwise not have if it were not for the fact that these relatively minor elements become major elements later on. Indeed, the connoissuership of art, especially in its concern with attributing and authenticating works, is completely dependent on such comparative procedures.

These same procedures can easily be applied to the study of whole periods in the history of art as well, so that it becomes possible to trace, for instance, the development of a Baroque style, or of landscape in nineteenth-century American art. In each case, the art historian is tracing the progress of a style or approach to representation as it develops, as it increases in sophistication and complexity. An important assumption is at work here. The assumption is that a later work is more sophisticated than an earlier work, that there is a progress towards increasing complexity. Given this assumption, how would you write an essay comparing an early work by a given painter to a later one, or an early Baroque painting to a later one? You would develop a simple thesis: that the later work grows out of and depends upon certain features found in the earlier work, and, further, that the later work subsumes the earlier work and takes the problems or themes that it deals with to a new level, arriving at a new synthesis of some kind. This is precisely the way in which the argument above concerning Sheeler's debt to Hicks was developed.

Comparative essays are also used to explain change—the change for instance from the High Renaissance style of Michelangelo to his later Mannerist work, or the change in Picasso's work from his Blue Period to his Cubist painting, or from Neoclassicism to Romanticism. Here we begin with two radically different works or styles of art that seem to have nothing in common. The task is to explain why the characteristic elements of the first work have been abandoned in the second. The project is still historical—the later work abandons the principles of the earlier work, and you are asking why. Your thesis, in this case, is your explanation of the change. You are comparing the two works in order to explain this change.

Often in a comparative essay, you are engaged in both these approaches. On the one hand, you see certain kinds of continuity. On the other, you see certain kinds of change. Those two words—*continuity* and *change*—are the basis of most comparative essays.

When choosing what to write about, always consider what advantages for you there might be in a comparative approach, and then ask yourself these two questions: What changes from piece to piece? What

stays the same? And then you must decide what all this means. What does this continuity or change tell us? What do we learn from the comparison? (If we learn nothing, then the comparison is not worth making, and you had better look for something else to write about.)

CHOOSING WORKS FROM "THE MUSEUM WITHOUT WALLS"

Writing about works of art seen in person has many advantages over writing about works one has seen only in books, but very often one has no choice. There is no substitute, for instance, for actually walking around, and under, Tom Morandi's *Yankee Champion,* a fifteen-foot high stainless steel sculpture on the campus of Portland State University in Portland, Oregon (Fig. 7). Named, more or less arbitrarily, after the New

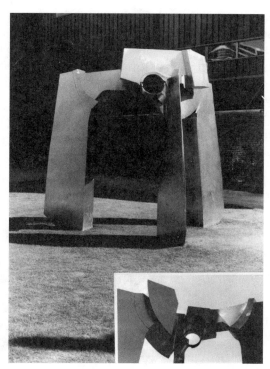

Figure 7 Tom Morandi, *Yankee Champion,* 1986. Stainless steel, height 15 ft., width 14 ft., depth 14 ft. Portland State University, Portland, Oregon.

Englander who lent Morandi the facilities to build the piece, the sculpture appears to be a large-scale precision instrument, or a modern day version of Stonehenge, its top horizontal pieces resting securely on its massive three-column base. But if you were to walk between its legs and peer up to where the legs meet, you would be astonished to discover that none of its three legs actually touches either of the others. Each rises fifteen feet and then reaches in toward the center, forming an arch that extends behind the circle, but several inches of empty space separate each from each. Suddenly the slight inward tilt of the three columns, visible especially at their base, seem ominous. It is as if what appeared to be a stable structure from the outside might at any moment collapse on you as you stare up from below. While in fact the sculpture is extremely stable, the viewer, seeing it in person, inevitably feels at risk. The piece is, furthermore, very different in look from one side to the other, and as the viewer walks around it, it changes. No single photograph can ever contain, or even hint at, its whole effect. Similarly, Gustave Courbet's giant canvas, *A Burial at Ornans* (Fig. 8), in the Musée d'Orsay, must be seen in person to be fully appreciated. Even though, in the harsh light of this particular museum, many of the details readily apparent in reproduction are virtually lost, the scale of this massive painting, which hangs over us like the rocks of Ornans in its background, can be experienced only firsthand. It is this scale, together with the tension one feels between the monumentality of the literal canvas and the triviality of the scene depicted, that provides one of the most important insights into the painting of Courbet and its influence on modern art.

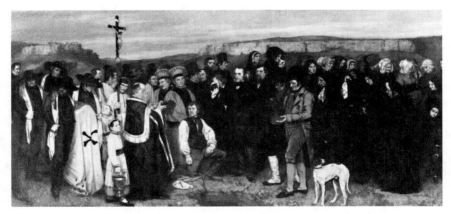

Figure 8 Gustave Courbet, *A Burial at Ornans,* 1849. Oil on canvas, 10 ft. 4 in. × 21 ft. 11 in. Musée d'Orsay, Paris. Giraudon/Art Resource, New York.

But most of us are condemned to what the French writer and novelist André Malraux called, somewhat more optimistically, "the museum without walls." What, Malraux asks, had the average expert on art, let alone the average citizen with an interest in art, actually see in the nineteenth century?

> Two or three of the great museums, and photographs, engravings, or copies of a handful of the masterpieces of European art. . . . In the art knowledge of those days there existed an area of ambiguity: comparison of a picture in the Louvre with another in Madrid, in Florence, or in Rome was a comparison of a present vision with a memory. . . . Today, an art student can examine color reproductions of most of the world's great paintings and discover for himself a host of secondary works, as well as the archaic arts, the great epochs of Indian, Chinese, Japanese, and primitive and "folk" art. How many statues could be seen in reproduction in 1850? . . . A museum without walls has opened to us, and it will carry infinitely farther that limited revelation of the world of art which the real museums offer us within their walls.[7]

There are, as Malraux points out, some real advantages in having so many reproductions available on our coffee tables in book form, but there are a number of factors that you need to consider.

First, and this may seem obvious, *never* write about a color work that you know only in black-and-white reproduction. Not only are you likely to make a mistake about the nature or feel of the work, but you are unable to discuss what may be one of the most important features of the work, its use of color. In Courbet's *Burial at Ornans,* for instance, a distinct positive/negative effect is created in the play of black and white between the two sides of the painting, a play accentuated by the dominance of red on the left side of the canvas, especially in the dress of the comical beadles. All this is lost in reproduction and, as a result, the unifying structure—and tension—of the painting's color scheme is lost as well.

Second, pay very close attention to the dimensions of the work, given in the caption to the reproduction (often this detail will be found only in a "List of Reproductions," or similar section, in a separate part of the book). Imagine, as accurately as possible, the size of the piece with which you are dealing. Is it very small, or very large? Does your sense of its size alter your response to it? It matters greatly, for instance, that you understand that the figures in Courbet's *Burial at Ornans* are nearly lifesize, that the painting is over 10 feet high and nearly 22 feet long.

Third, recognize that even in the best reproductions you can get only the vaguest sense of a particular work's texture, the tactile qualities of its surface, its literal "feel." In Cubist collage, for instance, it is often impossible to tell, except in the actual presence of the work, whether a particular passage in the work is drawn, painted, or glued on. A piece of delicately grained wood might be brown paper with the grain drawn on in pencil, or it might be simulated wood-grained wallpaper pasted onto the canvas, or it might be an actual piece of wood. Such distinctions might be important in a discussion of Cubism's delight in undermining traditional notions about distinctions between the artificial and the "real."

Finally, the quality of color reproduction varies widely, from book to book and even from image to image within a book. It is a good idea, whenever possible and especially when color is an issue that seems important to your discussion, to consult as many reproductions as you can locate. If there seems to be some question as to which reproduction is most accurate, ask your professor for an opinion. Very often your professor will have seen the work firsthand. Or turn to the World Wide Web.

THE COMPUTER AND "THE MUSEUM WITHOUT WALLS"

If photoreprodution in books created, in this century, a "museum without walls,"the development of the computer and the introduction of CD-ROM and the World Wide Web has tumbled the museums' walls even more dramatically. The great museum collections of the world are becoming increasingly accessible on disc and on-line, to the great benefit of art students everywhere.

The collection of the National Gallery in Washington, D.C., for instance, is available on CD-ROM. Most of the standard Web search engines—sites that provide search resources, including keyword searches, such as Yahoo!, WebCrawler, and so on (see Chapter 3 for more about these)—contain specific "Art" categories, and within "Art" many subcategories, including "Museums and Galleries." Here you can "visit" the most popular sites, and many previously unknown to you—from the Museum of Modern Art in New York and the Louvre in Paris, for instance, to the new Guggenheim Museum in Bilbao, Spain, designed by architect Frank Gehry, and the Isamu Noguchi Garden Museum in

Long Island City, Queens, New York, dedicated to the work of the modern Japanese-American sculptor. Each of these sites provides guides to their collections. And while some museum sites offer only a few examples of the work they house, others, such as the San Francisco Museum system, are attempting to make their entire collection available on the Web.

The advantages of viewing art on the Web are several. In the first place, provided that your own monitor is properly adjusted, color tends to be very true. Secondly, museums very often utilize "zoom" technologies that magnify the image to as much as double screen-size. Thus details not readily visible in book reproductions are rendered before you on the computer screen. Some museums even allow you to download their images and use them to illustrate your paper, provided the museum is properly cited (more on this in later chapters) and that your use is entirely educational and not-for-profit. If the the museum does not specifically grant such permission in their site, you *must* ask for permission before downloading and reproducing any image. Many images in museum sites are, in fact, not downloadable at all. Nevertheless, they represent a significant visual resource.

SUMMARY

You should approach the selection of a work to write about from a book with more or less the same degree of awareness and caution that you would employ in selecting a work to write about in a museum or gallery. In sum:

1. Determine in what ways the space of the museum or gallery (or the book) is potentially influencing your expectations. Have you come to the Guggenheim, for instance, because you want to see modern art?

2. Examine the context of the work of art that initially attracts you and determine in what ways that context informs your understanding of the work. Imagine it in some other context. Does this alter your perception of it? Are you attracted to the work despite its context or, and this is much more often the case, because of its context? Are you considering the work as art because you are seeing it in a museum or gallery? If you were to see Duchamp's *Fountain* in a plumbing store, for instance, would you look at its as carefully as you do in a museum?

3. Have you chosen a work that is rich enough to sustain an interest-ing essay? Will you have enough to say?

4. Have you chosen a work that interests you? Does it seem to pose special problems? Are you surprised at your interest in it? Can you begin to articulate what is interesting about it?

5. Are there other works that interest you as well? Do they seem to have something in common with the work that initially caught your eye? Do they shed light on it? Would discussing one or more of them help you to explain what interests you in the first work? How are they different? How are they the same? What kinds of continu-ity can you establish between them? What kinds of change are apparent?

6. Even if you find nothing of real interest to you, can you imagine that someone of relatively sophisticated taste and developed intel-ligence must find these works interesting enough to justify their exhibition, and can you begin to determine what the source of that interest might be?

These are all questions that you need to ask yourself even before you begin to write. They will help put you in the proper spirit—that is, in a *questioning* frame of mind. Even more to the point, they are likely to help you understand your own feelings about the work or works you want to write about before you begin to write your essay.

ART

2

USING VISUAL INFORMATION

What to Look for and How to Describe What You See

Probably the greatest stumbling block for most people confronting the prospect of writing about art for the first time is what they take to be the specialized vocabulary of the art connoisseur, a vocabulary with which they are not conversant. Actually, the vocabulary of good art writing is relatively simple and based on common sense. What is more esoteric and sometimes totally alien to the uninitiated is the jargon of technical and period styles that has developed as a sort of shorthand descriptive tool—a rhetoric that includes words like "classical," "baroque," "romantic," "modern," and "postmodern." If these words were not useful, they would not have the wide circulation that they do, but it is not necessary to feel comfortable with them in order to begin writing about art. They originate out of distinctions among the ways that subject matter, the more common elements of form, certain principles of composition, and questions of media are employed. Most of you are quite familiar with the less specialized vocabulary of art writing— words like "line," "color," "balance," "rhythm," "sculpture," and "video"—and this more usual (and useful) vocabulary is far less threatening and more accessible than concepts such as "baroque." But there are many ways in which you can use this less specialized vocabulary to

your benefit as a writer. What does it matter, for instance, that an artist employs line in a certain way, or that the elements in a painting repeat themselves in a visual rhythm?

It is important to point out here, again, that all art worth the name is a question of conscious choices. Given two points and the opportunity to draw a line between them, you can choose to draw a straight line, or a curved line, or a line that turns back on itself and meanders hither and yon until it finally ends. Your choice, which may or may not be deliberate and studied, reveals a good deal about your temperament and even about the way you approach the world in general. A work of art is a compendium of such choices. Artists, who make such choices as a matter of habit and profession, make them a good deal more deliberately than you and I. This is not to say that artists necessarily think out in advance the implications of every line they make, or every application of color. Any artist will tell you that much of what they do is intuitive. However, every artist has the opportunity to revise and redo each work, each gesture—and indeed very often artists take advantage of that opportunity. It is probably safe to assume that what you are seeing in a work of art is an *intentional* effect, that the artist knows what he or she is doing.

A summary of the kinds of choices an artist can make follows. Any work of art involves the artist in choosing among a number of different possibilities: the *subject matter* must be decided upon; the artist must choose which of the various available *media* is best to portray or express that subject matter; in achieving the work, the artist will employ the *formal elements,* such as line and color, in the distinctive and particular ways that are part and parcel of the artist's style or that express the artist's intentions in a clear way; and, finally, the artist will decide how best to organize these elements into a whole by means of what we call the *principles of design* or *composition.* The following sections will give you some sense of the things you need to consider when you are trying to decide what a particular work of art might be about or why it might be significant or interesting. This is by no means a complete survey of the various media, principles of design, or formal elements that artists have at their disposal. It is simply an outline of why an awareness of them might help you learn to ask the right types of questions and then write a better essay. If you need more information about any given element or principle, you can consult any of the many authoritative art appreciation texts, where most of this material is treated in greater detail.

CONSIDERING
THE SUBJECT MATTER
OF THE WORK

Subject matter is the sum of the identifiable objects, incidents, and iconographic or narrative references that are recognizable in a work of art. In representational painting, these references are sometimes clear. Iconographic references are symbolic conventions that are widely recognizable in a given culture: for instance, the meaning of the cross or a crown of thorns is widely known in the Christian West. Recognition of iconographic references depends upon one's familiarity with the culture at hand. Very often simply consulting the title will make a work's range of reference more explicit. In abstract painting, however, the title may or may not help you understand the subject matter of the work. *Full Fathom Five,* the title of the Jackson Pollock painting discussed in the next chapter (Fig. 23), is very helpful indeed, but *Painting I,* the title of a Mondrian painting discussed later in this chapter (Fig. 12), is less so. Motherwell's *Open* (on the front cover) lies somewhere in between. Still, it is possible to say even of the Mondrian that, since it announces no overt reference, its subject matter might be form itself. This is very often the case in nonrepresentational art.

One of the most important things for you to remember when discussing subject matter is that it is in no way comparable to the *meaning* of the work. One of the classic examples of this distinction between subject matter and meaning was developed by Joshua C. Taylor in his handbook, *Learning to Look.* Taylor points out that Pietro Perugino's *Crucifixion with Saints* (Fig. 9) and Carlo Crivelli's *The Crucifixion* (Fig. 10) have the same subject matter, but the meaning that subject matter assumes in each is dramatically different. For Taylor, the Perugino "would seem to quell the possible anguish and effects of suffering which might be associated with the scene and to establish a serenity and calm, a complete relaxation of the emotional and physical forces which might be expected to operate in connection with such a subject matter." In contrast, in the Crivelli there "is no rest, no calm, or contemplation. Instead we take upon ourselves the anguish and physical hurt which seem to motivate the actions of the figures. And nowhere is there escape, no point on which our attention can fix itself to bring order to our excited emotions."[1] There are many structural and formal reasons for this difference—and Taylor's analysis occupies ten pages of text—but it should be sufficiently clear that whatever meaning these works possess,

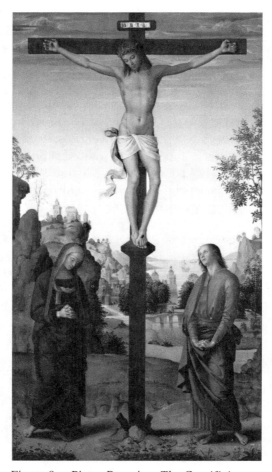

Figure 9 Pietro Perugino, *The Crucifixion
with the Virgin, Saint John, Saint Jerome, and
Saint Mary Magdalene* (central panel), c. 1485.
Oil on panel transferred to canvas, 39 ⅞ × 22 ¼
in. Andrew W. Mellon Collection, © Board
of Trustees, National Gallery of Art,
Washington, D.C.

it is independent of subject matter. It is as if one artist sees in the scene
the promise of salvation hereafter whereas the other sees the misery of
our life on earth in the here and now.

*One of the most common mistakes student writers make is to con-
fuse subject matter with meaning.* A typical sentence describing one of
these paintings might read: "Perugino [or Crivelli, take your pick] has
painted a crucifixion, with all that implies." The assumption here is
that the meaning of the crucifixion is clear, but such assumptions often

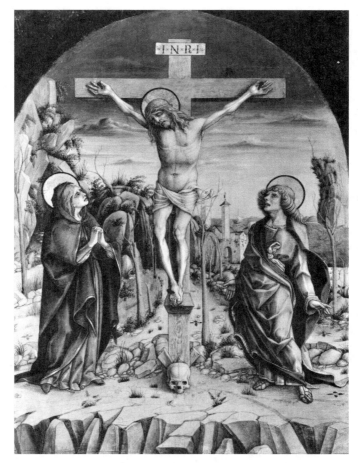

Figure 10　Carlo Crivelli, *The Crucifixion,* c. 1490. Tempera on
panel, 30 15/16 x 22 3/4 in. Wirt D. Walker Fund, 1929.862,
photograph © 1998 The Art Institute of Chicago. All rights reserved.

stymie the development of ideas. The crucifixion may imply something
very specific to the student writer, but Taylor's point is that the cruci-
fixion implies something entirely different to each painter, and that im-
plication may or may not coincide with what the writer feels about the
same subject matter.

One way to assess the meaning of a given work, then, is to try to
imagine other handlings of the same material. It should follow that one
of the best ways to write an essay about Perugino's *Crucifixion* is to
compare it with Crivelli's. From the differences between the two we are
able to recognize some of the important decisions that Perugino made
and thereby learn a great deal about his intentions.

Or imagine a painting of a red barn in a green field. What does it matter that it is bathed in sunlight? What is the effect of the startling color contrast between red and green, and how would the same scene feel handled monochromatically as a winter scene, in the snow, at dusk? Does it matter that the barn is silhouetted against the summer sky and that your point of view is relatively low? Does it make a difference that its lines and angles are clearly delineated? Would it seem less appealing, more lonely and foreboding, if it melded into the landscape and shadows? In short, given just such a set of questions and a broad enough selection of barn paintings, a reasonably significant essay on American attitudes toward landscape could probably be written. Similarly, art historians will often illustrate the difference between two stylistic periods or schools by comparing works of similar subject matter but distinctive handling. Even particular phases within an individual artist's career can be understood by means of this device. What, for instance, are the obvious differences in handling between the two versions of *Mont Sainte-Victoire* by Paul Cézanne that appear later in this chapter (Figs. 20 and 21), the second of which was painted nearly twenty years after the first? Don't you suppose that this difference tells you something about Cézanne's intentions?

Thus, while subject matter (or the lack of it, in a nonobjective painting) is the most readily apparent aspect of the work, it is also, by itself, one of the least useful in discussing the work's meaning. Rather than asking yourself what the subject matter of a particular work is, ask yourself, "What does the artist think of his or her subject matter?"

What artists think of their subject matter will be revealed in their handling of the various formal elements, the way they employ the principles of composition, and their choice of medium.

DESCRIBING THE FORMAL ELEMENTS YOU DISCOVER IN THE WORK

Line

Since line is the primary means we have for defining visual form, it stands to reason that it is one of the most important elements to be considered in preparing to write about a work of art. The difference in its use in the Perugino and Crivelli *Crucifixions* probably accounts more than anything else for the difference in meaning that we detect in these

works. In the Perugino, line is determined largely in relation to the strong vertical and horizontal axes defined by the cross itself. Working off these axes are a series of isosceles triangles, the most obvious of which is defined by the relative positions of the heads of the Virgin Mary and St. John at the two bottom corners, and Christ's head at the apex. The apex and central axis of each of the composition's other triangles remain constant, but a wider, higher triangle can be seen stretching across Christ's feet, each side defined by the trees left and right; another is defined by the outside legs of Mary and St. John, their toes pointing to the bottom corners of the triangle, and another by the almost perfectly balanced sweep of their garments across their legs. A smaller, more precise set of triangles can be seen emanating from the diamond shape of the cross at Christ's feet. Most subtle of all, this pattern is repeated in the folded fingers of both the Virgin and St. John. The curvilinear features of this painting, from the disposition of St. John's arms to the arched bridge in the background, seem to wrap around this triangular structure in the same manner that a circle fits neatly around an equilateral triangle.

In contrast, and although the cross divides the canvas more or less along the same geometric axes as in the Perugino, not a single line in the Crivelli seems to work in harmony with any other. If line seems to function in a more or less centripetal way in the Perugino, it is centrifugal in the Crivelli, as if erupting from the scene. Most tellingly, the painting's lines all seem to fall away from the central axis. Both the Virgin's and St. John's head tilt back rather than in toward the path of their gaze. St. John's hand points away from the scene. The effect is not unlike the curious sense of disorganization achieved by Courbet in his *Burial at Ornans* (Fig. 8). Despite the strong horizontal order achieved in Courbet's grouping, especially in relation to the landscape behind, and the verticality of the figures (a horizontal and vertical structure emphasized, as it often is in Western art, by the crucifix rising over the scene), Courbet fragments the composition by having each gaze—including the dog's—turn in a different direction. There is no *focus* to the scene. Implied lines of sight explode in every direction away from the supposed center of attention, the burial itself. Similarly, in the Crivelli the nervous fractures of the cliff at the painting's bottom serve to create a general sense of linear disorder which stands in stark contrast to the linear regularity and harmony of the cross, let alone the balance of the Perugino. This disorder is emphasized especially by the curved crack that seems to emanate from the skull, together with the clutter of linear detail in the painting—tufts of grass here and there, tree limbs reaching every which way.

To emphasize this difference, Taylor contrasts the treatment of St. John in both paintings. In the Crivelli, he notes,

> the vertical structure-line of the figure [i.e., the fact that he is standing up in a more or less vertical way] has little meaning with regard to the effect of the whole, because the diagonal lines of his cloak are so strong that they destroy all possible sense of a vertical compact mass. And consider the nature of the lines themselves. Every curve is flattened and broken so that the line seems to struggle to reach its destination. Furthermore, if we isolate the line of the cloak, we see that far from suggesting the balanced arc of a circle, it seems rather like the lash of a whip. And this eccentric line is repeated throughout, in the robe of the Virgin, in the rocks, and even in the body of Christ. How contrasting with this is our scheme of the St. John of Perugino. The lines of the Perugino seem to wrap themselves together into a smooth-planed volume, while those of the Crivelli disperse into the air.[2]

Even more than in the figure of St. John, the difference between the two paintings is manifest in the way that each recessional plane in the Perugino is clearly outlined, the landscape receding into the distance in a reasonable and logical way, while in the Crivelli the landscape seems hopelessly confused. Notice, in the Crivelli, how the drapery on Christ's right leg sweeps in a continuous line into the landscape beyond, how the tree, which must be some distance behind him, seems to catch the drapery in the wind, and how another tree behind St. John seems to merge into the cliff across the bay. In contrast, each plane in the Perugino is distinct. Line seems to serve a regulatory function. It is as if line preserves the integrity of the space it describes, whereas in the Crivelli it violates that integrity, disrupting our sense of organization, order, and harmony.

Shape and Space

It should be obvious, from the previous discussion, that one of the primary functions of line is to describe shape and space. One of the first questions to ask yourself about a work of art is *how* do its lines describe shape and space? In a consistent and orderly way? Or in an apparently disruptive, even random way? One of the most powerful effects of the painting of Jackson Pollock (Fig. 1) is that its line never quite manages to define shape, let alone a consistent space. Just as it approaches the definition of a shape, it seems to break off, move in another direction.

The lines of the painting seem either to pile up on one another, creating a kind of physical density and depth that seems almost galactic, or they thin out, especially at the edges, so that the painting seems flat and shallow. These are intentional effects, and they help to create a sense of ambiguity that is fundamental to Pollock's sensibility.

Normally, shape and space are defined in more consistent and accessible ways, although the lines operating to define these elements may not always be immediately obvious to you and may achieve very complicated effects. But if you learn to see these lines in the first place, and the shapes or spaces they describe, you can begin to come to grips with other, more complicated effects achieved by the artist. When you first look at Claude Monet's *Gare Saint-Lazare,* Paris (Fig. 11), for instance, you may not notice the diamond-shaped space that defines the center of the composition. Its top is defined by the roof of the train station, and its bottom is delineated by two implicit or compositional lines that meet

Figure 11 Claude Monet, *Gare Saint-Lazare, Paris: The Arrival of a Train,* 1877. Oil on canvas, 32 ¾ × 40 in. Courtesy of The Harvard University Art Museums (Fogg Art Museum). Bequest, Collection of Maurice Wertheim, Class of 1906.

in the hazy locomotive in the center distance and that run along the tops of the two closer locomotives on each side of the center track. The area is very interesting because it seems to describe both shape—a two-dimensional diamond on a flat plane—and space—the airy volume of the train station itself. In fact, the bottom two lines are achieved by Monet's reference to the traditional laws of *perspective,* the geometric system of compositional lines perfected in the Renaissance for rendering the illusion of three-dimensional space. Often imaged as a road (or set of railroad tracks!) disappearing into the distance, traditional perspective is based on the observation that parallel lines seem to converge toward a common point in the distance, referred to as the *vanishing point.* In the Monet the tops (and bottoms) of the trains converge on a hypothetical vanishing point that exists directly across from our point of view, somewhere behind the distant central locomotive. The serpentine central railroad tracks would also converge on this point if they were straightened out.

Thus, the bottom of the diamond shape is composed of two lines that define three-dimensional space, while its top is composed of the two lines that define the two-dimensional edge of the roof. Monet seems to be willfully playing off the illusion of three-dimensional space against the actuality of the two-dimensional surface of the canvas (paintings are, after all, two-dimensional planes), a sense of play that the curvilinear railroad tracks emphasize since they seem to be themselves a joke on the traditional representation of the laws of perspective. Why would Monet want to do this? Would it surprise you to discover that he was interested in drawing our attention not only to his choice of subject matter, but to his handling of it as well? Doesn't it make sense that he might want you to consider the surface of the canvas as a composition of effects to be enjoyed in their own right? His style of painting was as new in 1877 as the steam locomotive itself, and we move between them, the subject and its handling, in much the way that our eye moves between the two-dimensional design of the surface and the three-dimensional representation of space.

While Monet does not quite say that the design of the composition is more important than its subject matter, it is quite clear that, along with a number of his contemporaries, he initiates a logic that will eventually argue just that. Piet Mondrian's *Painting I* (Fig. 12), painted in 1926, almost fifty years after the Monet, has made that very step. Here the canvas is all surface; there is no illusion of depth; there is only a diamond-shaped plane, crossed by four lines, which themselves define the better part of what appears to be a square. This is a very difficult

type of painting for most students to talk about because it seems to have no subject matter. If you consider, however, that one of its primary objectives might be to free the painted surface of the necessity of representing three-dimensional space, then you might discover that you have something to say after all. The painting is about *form* itself.

Mondrian had some very particular notions about the meaning of form. He believed, for instance, that the most powerful of all abstract figures was the correspondence of the vertical and the horizontal line, particularly in the right angle. He believed this convergence embodied the unity of all opposites in the universe—male and female, plus and minus, good and evil, heaven and earth, and so on. Furthermore, the

Figure 12 Piet Mondrian, *Painting I,* 1926. Oil on canvas, diagonal measurements, 44 ¾ × 44 in. The Museum of Modern Art, New York. Katherine S. Drier Bequest. Photograph © 1998 The Museum of Modern Art, New York.

diamond shape embodied the union of the three material elements—
earth, air, and water—with the fourth, transcendent element—spirit.

Light and Dark

In addition to the traditional systems of geometric perspective, one
of the primary ways to evoke the illusion of three dimensions on a two-
dimensional plane is by imitating the effects of light as it falls on three-
dimensional surfaces. Gradual shifts from light to dark across the same
surface generally indicate that you are looking at a rounded or contoured
form. Georgia O'Keeffe's charcoal drawing of *Alligator Pears in a Basket*
(Fig. 13) is an almost classic example of this modulation, ranging from
the darkest blacks in its shadowed areas, through shadings of gray, to
highlights of white where an intense light strikes directly off the foremost

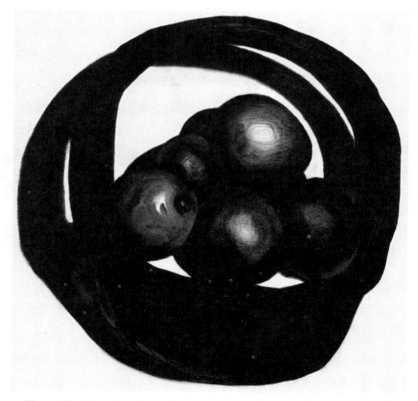

Figure 13 Georgia O'Keeffe, *Alligator Pears in a Basket,* 1923. Charcoal
on paper, 24⅞ × 18⅞ in. The National Museum of Women in the Arts,
Washington, D.C., Gift of Wallace and Wilhelmina Holladay. © 1999 The
Georgia O'Keeffe Foundation/Artist Rights Society (ARS), New York.

surface of the pears or off the back of the basket itself. This technique of creating the sense of a rounded surface by means of gradual shifts and gradations of light and dark was perfected in Renaissance Italy where it came to be known as *chiaroscuro*. In Italian, *chiaroscuro* means light (*chiaro*) to dark (*oscuro*)—and notice how language here reflects technique, as the end of the first word melds into the beginning of the second, creating a seamless transition between "light" and "dark."

The technique is used to great effect in Käthe Kollwitz's etching *The Downtrodden* (Fig. 14). Perhaps more than any other printmaker in

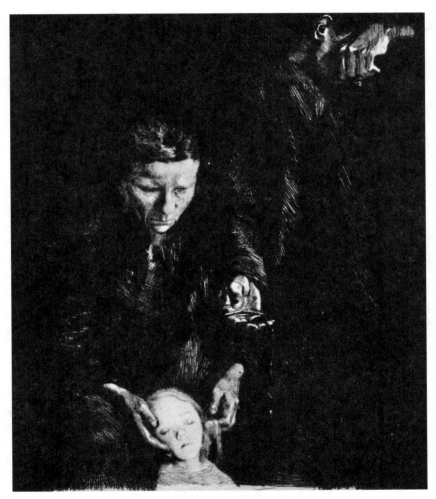

Figure 14 Käthe Kollwitz, *The Downtrodden,* 1900. Etching and aquatint on paper, 12 ⅛ × 9 ¾ in. The National Museum of Women in the Arts, Washington, D.C., Gift of Wallace and Wilhelmina Holladay.

history, with the possible exception of Rembrandt and Goya, Kollwitz was able to manipulate contrasts of light and dark to create highly dramatic and emotional images. In this etching, the figures barely emerge from a shroud of darkness. Only the edge of the father's hand, which hides his face in the upper right corner of the composition, and the angelic face of the dead child in the lower left corner are fully lit. Between these poles of light, poles of innocence and despair, the mother reaches down, letting the child's hair fall between her fingers. Just above, the father's hand reaches out aimlessly. And the mother's face, realized in a powerful middle-tone gray, displays an extraordinary range of emotion, at once infinitely sad and ultimately tired. It is as if Kollwitz's gray has become the very color of bitterness and resignation.

Sometimes you will encounter works of art that employ little or no contrast between light and dark. The light seems uniform throughout. If the drama in Kollwitz's etching is palpable, minimal contrasts of light and dark usually have the opposite effect. A work of art that seems uniform in tone, such as Perugino's *Crucifixion,* usually evokes feelings of calm and harmony.

Color

Though it is easier to think of questions of light in terms of black and white, the same rules apply to color as well. Think, for instance, of the difference between pink and maroon: one is red saturated with white and the other is red saturated with black. When we refer to someone who wears a lot of pastels, we mean someone who dresses in colors light in tone. It is not hard to imagine a painting of a red ball that moves in tone from a white highlight to a black shadow through all the various tints and shades of red (the color that results from adding white to a pure hue is called a *tint* of that hue, and the color that results from adding black to the hue is called a *shade*).

Yet color functions in works of art in terms more complicated than just those of light and dark. In fact, in the same way that black and white can be considered opposites, each color has its opposite number as well. These opposites are called *complementary* colors (spelled with an *e* not an *i*—one of the most common spelling mistakes made in art writing). Complements are pairs of colors that, when mixed together in almost equal proportion, create neutral grays, but that, when standing side by side, as pure hues, seem to intensify and even contradict one another.

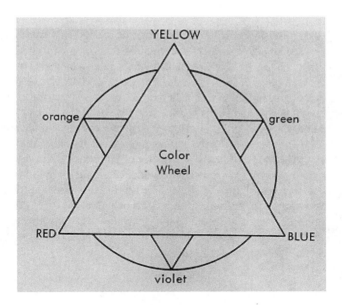

The traditional color wheel—reproduced on the next page—makes these oppositions clear. Each primary color—red, yellow, and blue—has, as its complement, a secondary color—green, violet, and orange, respectively. Thus, the standard complementary pairs are red/green, yellow/violet, and blue/orange (and, obviously, the intermediate hues have complementary opposites as well—the complement of red-orange is blue-green, for instance). Furthermore, just as gray moderates between black and white—as white becomes gray with the addition of black and vice versa—each color gradually moderates into the hue of its neighbor with the addition of its neighbor. Thus, the more yellow one adds to green, for instance, the more yellow-green the color becomes. Neighboring colors on the color wheel are called *analogous* colors. Unlike complementary pairs which create a sense of contradiction or opposition to one another, analogous pairs usually seem to rest harmoniously beside each other. The analogous blue-green-violet relationships are commonly referred to as *cool,* and red-orange-yellow combinations are said to be *warm,* or even hot.

Color theory is a vastly complicated field—one that is hardly settled, even among physicists—and the scheme described above is a vast oversimplification of the ways in which colors interact. (If you wish to explore color interactions more fully, try to locate Josef Albers's *Interaction of Color,* originally written in 1963, but reissued in 1993 in an

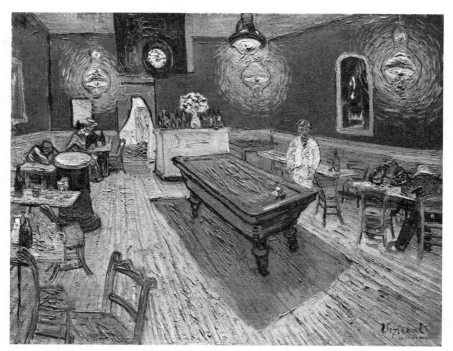

Figure 15 Vincent van Gogh, *The Night Café,* 1888. Oil on canvas, 28½ × 36¼ in.
Yale University Art Gallery, Bequest of Stephen Carlton Clark, B.A. 1903.

interactive CD-ROM edition by the Yale University Press. Here you
can have hands-on experience manipulating and experiencing the prop-
erties of color in a simple, easily accessible format.) Nevertheless, in
writing about art, it is important to understand the basic complemen-
tary and analogous groupings because a great many works depend
upon them to some degree in order to achieve their effects. Much of the
power of Vincent van Gogh's painting, for instance, depends upon his
use of complementary color schemes. In a letter to his brother Theo, he
described his famous painting *The Night Café* (Fig. 15) in the follow-
ing terms:

> In my picture of the "Night Café" I have tried to express the idea that the
> café is a place where one can ruin oneself, run mad, or commit a crime.
> I have tried to express the terrible passions of humanity by means of red
> and green. The room is blood-red and dark yellow, with a green billiard
> table in the middle; there are four lemon-yellow lamps with a glow of or-
> ange and green. Everywhere there is a clash and contrast of the most
> alien reds and greens in the figures of little sleeping hooligans in the

empty dreary room, in violet and blue. . . . The white coat of the patron, on vigil in a corner, turns lemon-yellow, or pale luminous green.

So I have tried to express, as it were, the powers of darkness in a low wine-shop, and all this in an atmosphere like a devil's furnace of pale sulphur. . . . It is color not locally true from the point of view of the stereoscopic realist, but color to suggest the emotion of an ardent temperament.[3]

The color scheme, especially the contrast between the complements red and green, is meant to suggest the tension of the scene, the sense that beneath the surface an almost violent energy or fury is about to erupt. Things do not go together here, either literally or pictorially.

In a painting such as Pablo Picasso's *Woman with Book* (reproduced on the back cover), virtually the full range of complementary contrasts is employed. Yet, surprisingly, the painting seems to be unified in its overall effect. Except for the presence of a profile that does not seem to be her own in the mirror behind the seated woman—an image that suggests an intruder or an unseen observer, perhaps the painter himself—nothing of the tension and turmoil of van Gogh's painting seems to inform our vision. Rather, we observe a woman in meditation, gazing vacantly up from her book, daydreaming. Picasso's painting, as opposed to van Gogh's, is not a nightmare, but a reverie.

This is surely the result, in part, of Picasso's subject matter: His model is Marie-Thérèse Walter, who was also his mistress. But it is also a result of the fact that he is trying to make contrasting elements work together in harmony. Just as he has rendered the face of Marie-Thérèse simultaneously in both profile and three-quarters view, just as he made her seem at once fully clothed and half-naked, Picasso's sometimes stridently discordant colors here manage to coexist. Apparently, given the blackness outside the window to the left, it is night, and the darkness outside contrasts strongly to the brightness inside. Notice how the shadowed side of Marie-Thérèse's face is rendered in green and violet and how these two colors dominate the darker, cooler side of the painting. On the other side of the painting, the warm red glow of the chair, its orange back topped by the yellow frame around the mirror, seems almost to generate heat. It is as if Picasso has realized here something of which van Gogh only dreamed. In the same letter to his brother Theo in which he described the color effects of *The Night Café*, he claimed that he was always in hope of expressing "the love of two lovers by a marriage of two complementary colors, their mingling and their opposition, the mysterious vibrations of kindred tones."[4]

Neither Picasso nor van Gogh is interested in representing the precise color of the scene. The Impressionists had freed painting of the necessity of representing *local* color (that is, the color we "know" a thing to be in the sense that we "know" trees are green) and chose to represent the *optical* color of what they saw (in the sense that a hill covered with "green" trees will appear to be blue in the distance). Picasso and van Gogh have gone even further. "Colors, like features," Picasso would later write, "follow the changes of the emotions."[5] As opposed to van Gogh's, however, Picasso's emotions here run toward the loving and affectionate. One of the most widely known books of Picasso's day was an occult classic, first published in 1901, called *Thought-Forms,* written by Annie Besant and C. W. Leadbeater. It contains a "Key to the Meaning of Colors" outlining which emotions are connected to which colors, and not surprisingly, mint green, the color of Marie-Thérèse's hair, is the color of "sympathy," and violet, the other color that dominates her face, suggests "love for humanity." More precisely, violet is "a mixture of affection and devotion . . . and the more delicate shades of [it] invariably show the capacity of absorbing and responding to a high and beautiful ideal."[6] Picasso might not have read the book, but its classifications were so popular that he almost could not have escaped them, and, evidently, they are at work here.

It should be clear, however, even from this brief discussion, that different artists use color in different ways. Yellow may be "sulphurous," as it was to van Gogh, but to someone else it may suggest the "highest intellect"—the meaning, in fact, given it by Besant and Leadbeater. Combinations of complementary colors may create tension in a painting, or they may be harmonized. Analogous color schemes often create a unified effect, but just as often that sense of unity can transform itself into a feeling of monotony. Meaningful discussions of an artist's use of color must often rely on a context greater than the individual work—as I have relied on the artist's own words, in the case of van Gogh, and upon intellectual history, in the case of Picasso.

As a writer, you must always be aware of the fact that the associations you have with a particular color are not universal. If you hear, "red," you may think "roses" and "love" while the next person thinks "blood" and "anger," while the next person thinks "communism." If van Gogh's lines seem violent and disruptive, for instance, this impression would support your notion that he is employing complementary colors in order to create a sense of disunity and chaos. Ask yourself, how does the artist employ color and what does it mean? *But*

then ask yourself, do other things about the composition support this reading?

Other Elements

There are a number of other formal elements that might be important for you to consider. What, for instance is the *texture* of the work? If it is uniformly smooth, does this smoothness contribute to a sense of harmony? Consider van Gogh's *Night Café* again. Doesn't the thickness of the brushstroke, its very assertive and gestural presence, express his emotional involvement in the scene at the café?

Another formal element, one not quickly associated with art, is time. Time becomes a factor in Tom Morandi's *Yankee Champion* (Fig. 7) when we find ourselves walking around and through it, recalling on our experience of it on the outside as we stand looking up through it on the inside. The sculpture changes, furthermore, as the light changes, the stainless steel reflecting changes in season and weather. The sculpture, in fact, is dynamic rather than static, active rather than passive.

Similarly, the garden Isamu Noguchi designed for the museum dedicated to his work in Long Island City, Queens, is a dynamic space (Fig. 16). In Japanese gardens, each of the stone sculptures is believed to be connected to the others, as if each were rising out of the great mass of the earth's core. We enter a garden, we recognize that we are "floating" on the world beneath. As we move through it, the garden changes. As Noguchi himself describes it: "Its viewing is polydirectional. Its awareness is in depth. With participation of mobile man all points are centered. Without a fixed point of perspective all views are equal, continuous motion with continuous change."[7] Noguchi also feels that the stones in a garden embody a sense of time comparable to human time: "Their weathering seems to coincide . . . with our own sense of historical time. . . . There is a time passage to stone not unlike our own. A mellowing takes place."[8] Thus in the garden we experience time in its vast geological sense (through the stones' connection to the earth mass below), in terms of the span of human life, and in "real" time, as we walk through the garden in the present moment itself.

Time entered the domain of art in radically new terms with the invention of photography in the last century. Photography seems to convey the essence of a particular time and place, and this aura of authenticity, together with its sense of instantaneous vision, of the moment itself

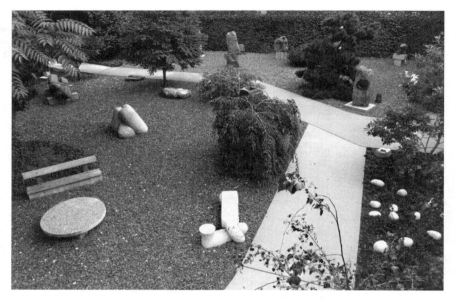

Figure 16 Isamu Noguchi, Sculpture Garden, Isamu Noguchi Garden Museum, Long Island City, Queens, New York, 1987. © Shigeo Anzai, courtesy of the Isamu Noguchi Foundation, Inc.

captured forever, constitutes a large part of its appeal. Today, it is apparent that the dialogue between the present moment of our seeing the photograph—our actual experience of it in "real" time—versus the way in which the photograph seems to embody, or make present, something long lost or far away, has revolutionized our sense of time and space.

For Henri-Cartier Bresson, one of the pioneers of photography in this century, the appeal of the medium rested in its simultaneous sense of the timelessness of formal composition and the instantaneousness of its depiction. Thus, the leaping man in his 1932 photograph *Gare St.-Lazare* (Fig. 17) is suspended above his own reflection, which creates a sense of balance in the photograph. But his leap is also reflected on the circus poster on the wall behind him, just as the semicircular arched back of the poster figure is echoed in the semicircular form in the foreground water. In fact, the reflection in the water eerily mirrors the poster on the wall. Cartier-Bresson called this the "decisive moment"—the photographer realizes that "by releasing the shutter at that precise instant," he has "instinctively selected an exact geometric harmony, and that without this the photograph would have been lifeless."[9]

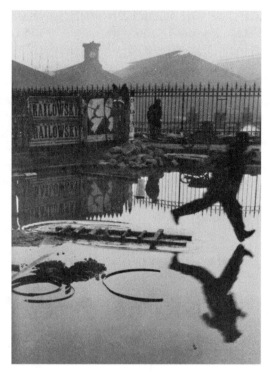

Figure 17 Henri Cartier-Bresson, *Gare St.-
Lazare,* Paris, 1932. Magnum Photos Inc.
© 1995 Henri Cartier-Bresson.

Two other art media—video and film—rely even more on time.
One of the traditional distinctions among the arts has been that the plas-
tic arts—painting, drawing, and sculpture—are *spatial* media, while the
other arts—dance, music, literature—are primarily *temporal* and *linear*
in nature. Video and film are both.

Most of us think of video in relation to commercial television.
However, many video artists purposefully manipulate the medium in
order to distinguish what they do from the television we habitually con-
sume. The most common difference, again, is the medium's relation to
time. Standard television time is based upon the length of the commer-
cial—10, 30, 60, and, less commonly, 120 seconds in duration. As David
Antin has pointed out in a detailed analysis of the medium, there is re-
ally no difference between commercial time and the structure of time in
television programs generally. A news "story," for instance, generally

fits into this same time scheme, and a baseball game is a succession of pitches, hits, and catches that fit the same pace.[10] Video artists often ignore this pace completely, so to a viewer expecting "television," their work usually seems boring. Very commonly, the camera is held in one position, for as long as an hour. In this way, other aspects of the medium that are generally ignored, such as the peculiar way that video represents and distorts deep space, are foregrounded.

Video artists also commonly create installations in which the viewer encounters the medium as part of a larger, sculptural space. Bill Viola's *Room for St. John of the Cross* (Fig. 18), for instance, contrasts the stillness of a single image of a mountain shown on a small monitor in a cubicle at the center of the room (a space comparable to the "meditative " space of St. Jean, and a video projection of large snow-covered mountains, shot with a hand-held camera in wild, breathless flights of movement. The world "outside," in other words, contrasts with the world "within."

Perhaps one of the best ways to think of film, which can reproduce space in ways far more sophisticated than can video, is as an assemblage of various spatial and temporal points of view. The fade-in and fade-out, flashback and flashforward, closeup and longshot, and even the multi-image screen, all combine to produce film's many, sometimes startling visual effects. This multiplicity of visual techniques combines with the more purely temporal means of narrative, dialogue, and musical score to create one of the most complex of the arts.

Figure 18 Bill Viola, *Room for St. John of the Cross,* 1983. Video/sound installation. © Bill Viola. Collection: Museum of Contemporary Art, Los Angeles. Photo by Kira Perov/Sauidds and Nunns.

Figure 19 Lynn Hershman, *Lorna: The First Interactive Laser Video Art Disk,* 1983. Interactive video disk. Courtesy the artist.

Finally, of all the new media, the computer offers the artist a unique new set of possibilities, opening the image to the possibility of manipulation by the audience. Lynn Hershman's *Lorna: The First Interactive Laser Video Art Disk* (Fig. 19) is a pioneering example in the field. Created in the early 1980s, it is a conscious attempt to make the viewer participate in the work of art. As described by Hershman, the character Lorna is "a middle-aged, fearful agoraphobic, [who] never leaves her tiny apartment. . . . The more she stays home and watches television, the more fearful she becomes, primarily because she absorbs the frightening messages of advertising and news broadcasts." She is, in short, the classic victim of the society of the spectacle; like the television monitor itself, she is a passive receiver, but unlike the monitor she transmits messages to no one. She is like a television playing to an empty room . . . until Hershman enters the scene and admits the "viewer/participant." The viewer/participant alters the mix:

> Every object in Lorna's room is numbered and becomes a chapter in her life that opens into branching sequences. The viewer/participant accesses information about her past, future and personal conflicts via these objects. Many images on the screen are of the remote control device Lorna uses to change television channels. Because the viewer/participant uses a nearly identical unit to direct the disc action, a metaphoric link or point of identification is established between the viewer and Lorna. The viewer/participant activates the live action and makes surrogate decisions for Lorna. . . . Lorna's passivity (presumably

caused by being controlled by the media) is a counterpoint to the direct action of the participants.[11]

Hershman's piece is an early example of the ways in which interactive computer media are altering the relationship of art to its audience. The audience will not always create the most "aesthetic" or "artlike" outcome. But with programs such as this, the audience will always be able to try again, and again. It is also worth considering that when you write about art, you are already interacting with the work of art. In the act of writing, you are no longer a passive receiver but an active participant in its world. In many ways, especially if you take your participation seriously, the *act* of writing can empower you.

RECOGNIZING
THE PRINCIPLES
OF DESIGN

Rhythm and Repetition

One thing that would suggest that the traditional distinction between spatial and temporal media might not be altogether valid is the sense of visual rhythm and repetition we often experience before works of art. Certain formal elements—lines, shapes, colors—recur, in either exact or analogous terms, and this repetition creates a sense of visual rhythm that is analogous to musical or poetic rhythm. In all the arts, rhythm and repetition serve to organize, or order, the work into distinct and recognizable patterns.

Paul Cézanne's *Mont Sainte-Victoire* (Fig. 20) is composed of a number of repeated shapes and lines that serve to unify the composition. Notice that the slope of the mountain itself is repeated down the right edge of the top of the central tree, again with uncanny accuracy in the branch that extends from the right side of the tree halfway down its trunk, and again, immediately below that, in the large curve of the river. The shape of the river on the left of the tree seems to echo, in reverse, the hill that comes into the composition from the right. A rhythm of arches extends the length of the railroad viaduct, and throughout the painting, small, square, and rectangular areas—buildings, roofs, chimneys, fields—echo and repeat each other's shapes. In a later version of this same motif (Fig. 21), the precise elements of the landscape have virtually

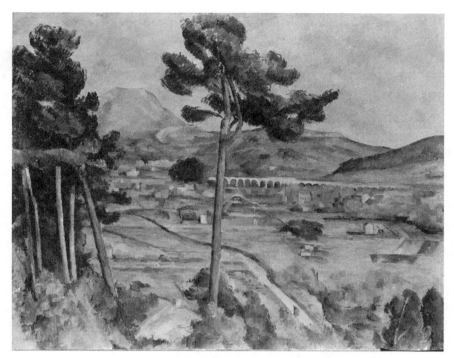

Figure 20 Paul Cézanne, *Mont Sainte-Victoire,* 1885-87. Oil on canvas,
25 ¾ × 32 ⅛ in. The Metropolitan Museum of Art, Bequest of Mrs. H.O. Havemeyer,
1929. (29.100.64)

disappeared, yet here the small quadrilateral shapes—which now see to
have been created by single brushstrokes, moving in a sort of pulse
through the composition—ascend toward the top of the mountain in a
rhythm and movement of growing clarity and definition finally achieved
by Cézanne at the painting's (and the mountain's) summit.

Balance

If you compare Cézanne's 1885-1887 version of *Mont Sainte-
Victoire* (Fig. 20) to Perugino's *Crucifixion* (Fig. 9), you will notice that
one thing these very different paintings have in common is that they can
be divided into more or less equal quarters across the axes formed, in the
Cézanne, by the central vertical tree and the arched railroad viaduct
and, in the Perugino, along the vertical axis of the cross and the horizon
line. This geometric division, which echoes and reinforces the shape of

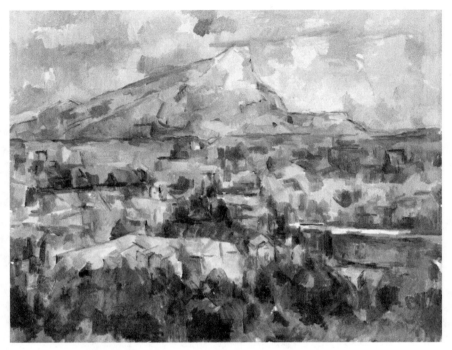

Figure 21 Paul Cézanne, *Mont Sainte-Victoire,* 1904-6. Oil on canvas,
27⅞ × 36⅛ in. Philadelphia Museum of Art, George W. Elkins Collection.

the frame in each painting, creates a sense of symmetry and equilibrium in both compositions. The sense of disequilibrium apparent in Crivelli's *Crucifixion* (Fig. 10) derives in large part from the fact that, despite its overall symmetry and balance on a vertical axis, created by both the cross and the overriding arch, there is no clear horizontal symmetry, and the structure of the right side of the composition seems radically different from the structure of the left. It is as if Crivelli has purposefully defied our expectation of balance.

There are many other ways to achieve a sense of balance in a composition. *Radial balance* is created when all the elements of the composition seem to emerge from a real or actual focal point. Many work of art utilize on *asymmetrical balance* in which a perceived center of gravity seems to balance elements around it. It is like balancing a teeter-totter with a very heavy child on one side and a light child on the other: the heavy child moves toward the center of the teeter-totter while the lighter child sits on the very end. Furthermore, relatively dark shapes seem "heavier" to the eye than lighter ones. In Piet Mondrian's *Painting I*

(Fig. 12), the lines on the right and bottom sides of the composition are wider than the lines on the left and top, and Mondrian balances the central square in the diamond shape by moving it to the right, so that more of the square is visible on the left.

Proportion

Proportion is the relationship of each part of the composition to the whole and to each other part. An excellent example of its use can be seen in the 1904-1906 version of *Mont Sainte-Victoire* (Fig. 21). You will notice that the composition is divided neatly at the foot of the mountain. This line, with the mountain and clouds above it and the countryside of Aix-en-Provence in southern France below it, very closely corresponds to what the ancient Greeks referred to as "the golden section." This proportion—which is found, incidentally, in living organisms—can be defined mathematically as follows: The smaller section (in the Cézanne, the area above the line running across the bottom of the mountain) is to the larger section (the countryside below) as the larger section is to the whole painting. In numbers, each ratio is 1 to 1.618. Not only did the Greeks use this "ideal" or "perfect" proportion as the basis for constructing their greatest buildings, but they conceived of the human body in the same terms. The perfect body, they reasoned, consists of a torso and head roughly equivalent to the vertical height of the top of the Cézanne composition, the body from the waist down equivalent to the lower part of the composition. Such proportional ideals, it is worth suggesting, dominate our visual thinking to this day—from our sense of when a landscape painting "feels" right to our sense of the ideal human form.

Scale

Scale is an issue with which we have dealt already in relation to the "museum without walls." It is sometimes very difficult, for instance, to get an accurate feeling for a work of art's size from a photograph of it. To get a sense of this principle, you need only think again of the actual size of Courbet's *Burial at Ornans* (Fig. 8) and the viewer's inability to take it all in at once, compared with the sense of containment one feels before it in reproduction. Similarly, only from a series of photographs or from the film can you get a sense of the many elements of Noguchi's Sculpture Garden (Fig. 16).

Other, more subtle effects can be achieved by manipulating scale. In Cézanne's 1885-1887 *Mont Sainte-Victoire* (Fig. 20), for instance, there appears to be a large bush or tree at the end of the railroad viaduct just to the left of the central tree. If it were really a tree, however, it would be 300 or 400 feet tall. It is, in fact, part of the pine in the foreground. In a very subtle move here, Cézanne purposefully draws the most distant planes of the canvas up to the closest by confusing our reading of what is near and what is far away. As a result, our attention is drawn to the surface of the composition, to its organization as a design, as much as to its representation of a three-dimensional world.

Scale is relative. That is, we define the scale of an object in terms of its relation to other objects around it. Thus, the two video images in Bill Viola's *Room for St. John of the Cross* (Fig. 18) are very different in scale—one large, one small—and this difference in scale contributes to the work's disorienting sense of space. In another example, the artist Nikolai Buglaj has transformed a classical example of an optical illusion created by a shift in the context in which objects are perceived into a commentary on race relations in the United States (Fig. 22). The three figures in this piece are all the same size (if you don't believe it, measure them for yourself), but because the figure outside the room is, in effect, contextless, he looks small. The figure entering the room appears

Figure 22 Nikolai Buglaj, *Racial Optical Illusion,* 1997. Pencil and ink on paper, 30 × 40 in. Courtesy the artist.

to be larger, and the figure inside the room appears largest of all. The surrounding walls alter the relative scale in which each figure is perceived. The wall of the room is decorated with an American flag, and it represents, for Buglaj, the "system" from which African Americans are excluded, thus making them appear smaller than they are. Conversely, from the outside looking in, the white man is appears larger than he really is.

Unity and Variety

One of the primary sources of interest and power in many works of art is the way their various elements are combined to create a sense of oneness or unity. Picasso's *Woman with Book,* for instance, on the back cover, is almost wildly diverse in its color, but its pattern of repetitive shapes unifies it. Round forms—from necklace, to armchair, to Marie-Thérèse's breasts—draw the various colors together, as do the teardrop shapes that make up both sleeves of Marie-Thérèse's dress as well as the bodice of her dress. In fact, the pattern of interlaced curves that circulate around and across the model's body unifies the entire composition.

CONSIDERING QUESTIONS OF MEDIUM

This is not the place to discuss the various capabilities and advantages of the specific media—painting, printmaking, drawing, sculpture, architecture, photography, video, film, fiber, ceramics, metal, and glass. Each has its distinctive features, and within each there are various subcategories—in painting, for instance, there is oil, acrylic, watercolor, tempera, gouache, and so on—that can elicit far different effects in themselves. You do need to keep in mind, however, the important differences between the two-dimensional media, the three-dimensional media, and those newer forms that combine the spatial sense of the plastic arts with the temporal forms of the other arts (i.e., video, film, and to some extent, photography). These distinctions have already been brought to your attention. Nevertheless, if you feel you are looking at a work that seems informed particularly by the choice of material, then by all means learn what that choice of material entails and implies. Doing so may involve a little research, or a few well-placed questions, but trust your instincts and follow up hunches like this. The ability of acrylic

paints to act in solution more or less like watercolor, for instance, allowed abstract painters in the 1950s to achieve certain stain techniques on canvas that had never really been possible before.

ASKING YOURSELF ABOUT THE WORK OF ART: A SUMMARY

The following set of questions derives from the previous discussion and is meant as a quick reminder of the kinds of things you might ask yourself about a work of art. It is by no means complete, and you almost surely will discover that most works of art raise other questions as well. Nor will every question be of particular importance in your coming to terms with each work you see. Still, this summary list does provide you with a model of the kind of analytical process that will help you understand what you see.

One last word of warning: Don't take these questions as an outline of your eventual paper. Good essays are never written by answering a series of predetermined questions. Consider them, rather, as a guide designed to help you take the notes and organize the thoughts that will eventually lead to writing a good essay.

QUESTIONS TO ASK BEFORE WRITING ABOUT A WORK OF ART

What is the subject matter of the work?

- What is its title?
- Does the title help you interpret what you see?
- Can you imagine different treatments of the same subject matter that would change the way you read the work?

Consider the formal elements of the work and how they relate to its subject matter:

- How is line employed in the work?
- Does it seem to regulate or order the composition?
- Does it seem to fragment the work?

- Is it consistent with traditional laws of perspective or does it violate them?
- What is the relation of shape to space in the work?
- How do light and dark function in the work? Is there a great deal of tonal contrast, or is it held to a minimum?
- What is the predominant color scheme of the work? Are complementary or analogous colors employed?
- What other elements seem important? Is your attention drawn to the work's texture? Does time seem an important factor in your experience of the work?

How are these elements organized?

- Is there significant use of visual rhythm and repetition of elements?
- Is the composition balanced? Symmetrically? Asymmetrically? Do various elements seem proportional, and how does the question of scale affect your perception?
- Does the composition seem unified or not?

How has the artist's choice of medium played a role in the presentation of the various elements and their organization or design?

- Are effects achieved that are realizable only in this particular medium?
- If more than one medium is involved, what is their relation?

What does all of this *mean?*

- What is the artist trying to say about the subject matter of the work? What feelings or attitudes does the composition seem to evoke, and what specific elements or design choices in the composition account for these feelings?

ART

3

RESPONDING TO THE VERBAL FRAME

Where Else to Look for Help in Understanding What You See

Every work of art is framed, not just in the way that a painting is contained within either a simple or ornate frame, nor in the way that the "white cube" of the exhibition space "frames" our vision, but by a verbal frame— the discourse that surrounds the work. Artists could be said to write about their works each time they title them. Sometimes they have even more to say. They might contribute artist's statements to exhibitions or grant interviews about their work. Often they become friendly with professional writers, who in turn write about the work from a more or less "insider" point of view. In time, articles appear, and books are published. Vast quantities of material might surround a given artist's work. The more you can take advantage of this verbal frame, the better off you will be. The task of moving from image to word is never an easy one, and by paying attention to the ways in which works of art are described, analyzed, and discussed by others, you can ease your task as a writer considerably.

TAKING THE TITLE AND LABEL INTO ACCOUNT

On the third floor of the Museum of Modern Art in New York City, in one of the first of the galleries dedicated to contemporary art, a

comparatively small, dark green painting by Jackson Pollock (Fig. 23) is sometimes on display. It is, at first glance, not nearly as engaging as some of the larger works by Pollock or his abstract expressionist colleagues that occupy most of the later rooms. It lacks their size and, given the more or less ominous and dense tone of the composition, quite apparently their visual variety and interest. It is not hung in any way that indicates that you should pay special attention to it. You assume, rather, that it is placed here as a kind of antecedent to the later, greater works to follow.

However, it is a very interesting painting, which you might discover if you have the time and the inclination, and if you take the

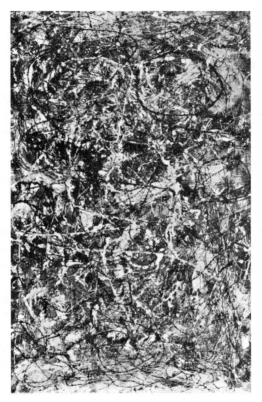

Figure 23 Jackson Pollock, *Full Fathom Five,*
1947. Oil on canvas, with nails, tacks, buttons,
key, coins, cigarettes, matches, etc., 50⅞ ×
30⅛ in. Collection, The Museum of Modern
Art, New York. Gift of Peggy Guggenheim.
© 1998 Pollock-Krasner Foundation/Artists
Rights Society (ARS), New York. Photograph
© The Museum of Modern Art, New York.

opportunity to stroll up to it and read its title: *Full Fathom Five.* This title immediately tells something very specific to someone familiar with Shakespeare. But even to someone for whom the phrase is unfamiliar, a certain resonance immediately develops that alters one's sense of the painting. You might know only that the word "fathom" is a nautical measure of depth, but suddenly, when you look back at the canvas, at its deep green recesses, you are underwater.

The title is the first verbal clue that you are given about the meaning of the work. It never ceases to astonish me how often students simply ignore the title in their discussion of a work of art. A colleague of mine once had a student who began an essay on Marcel Duchamp's *Nude Descending a Staircase* by writing, "In this painting, Duchamp depicts a person going up the stairs." This is a particularly vivid example of a quite common occurrence. The title, in fact, is one of the first pieces of information you must take into account. It is sometimes of no apparent help at all, but even in that case you can surely recognize that, for whatever reasons (reasons that you need to begin to figure out, incidentally), the artist has chosen not to help you, or has decided to confuse you. Not long after Pollock painted *Full Fathom Five,* he stopped naming his paintings and started numbering them. In a 1950 interview with Pollock and his wife Lee Krasner in *The New Yorker,* Krasner explained: "Numbers are neutral. They make people look at a picture for what it is—pure painting." Pollock then clarified her point: "I decided to stop adding to the confusion. . . . Abstract painting is abstract. It confronts you."[1] You may feel, in the case of *Full Fathom Five,* that the title does indeed add to the confusion. You probably will know that it's a quotation, but you may not recognize that it's from Shakespeare, let alone which play (more than one student has assumed that it's a reference to Jules Verne's *Twenty Thousand Leagues Under the Sea*). Nevertheless, it is worth suggesting that the difference between *Full Fathom Five* and some of the later, numbered Pollock paintings is that the former doesn't confront you in the way that a painting like *Number 1, 1948* (Fig. 1) does. The scale of the two paintings is dramatically different. *Number 1, 1948* is 5 feet 8 inches high and 8 feet 8 inches long. It literally surrounds you. *Full Fathom Five* is a comparatively small, dark painting. It needs its title.

When you encounter a title you don't understand, ask somebody if they recognize what it refers to. Or consult *Bartlett's Dictionary of Quotations.* The multivolume *Oxford English Dictionary,* although intimidating, can be particularly useful for old-fashioned and archaic meanings, since each entry consists of a history, with examples, of the various usages any given word has undergone. Whenever there's a word in a title

that you don't understand, look it up. Sooner or later, the reference will usually become clear. Occasionally, it is beneficial to look up a word you think you understand. The contemporary abstract painter Robert Motherwell entitled a group of his paintings the *Open* series because the word "open," which seems simple enough, is actually extremely rich in meaning.

Pollock's reference, in *Full Fathom Five,* is to Shakespeare's play *The Tempest* (even the title of this play seems to resonate in the dark swirl of the canvas). Early in the play, Ariel, an "airy spirit," as Shakespeare calls him, sings this song to Ferdinand, the son of the King of Naples, who has just come ashore after a shipwreck in which, he believes, his father has been lost. The song leads him to believe that the island is somehow magical and enchanted:

> *Full fathom five thy father lies;*
> *Of his bones are coral made;*
> *Those are pearls that were his eyes;*
> *Nothing of him that doth fade*
> *But doth suffer a sea-change*
> *Into something rich and strange.*
>
> (*Tempest,* I, ii)

These are words that help you understand the painting. Pollock has led you in their direction, and he intends for you to consider them. They *frame* the painting in a way you cannot afford to ignore.

What they suggest, first of all, is that some sort of "sea-change" has occurred in the painting that has transformed its elements into something "rich and strange." You should ask yourself, "Well, what are the elements of this painting?" Is there anything special about them? Again, if you were to go back to the label accompanying the Pollock painting, to the verbal frame, you would find some additional help. It reads: "Jackson Pollock, *Full Fathom Five,* 1947. Oil on canvas, with nails, tacks, buttons, key, coins, cigarettes, matches, etc., $50\frac{7}{8} \times 30\frac{1}{8}$ in." You go back into the painting and consider it more closely, looking to see if you can detect this accumulation of material in it. And, of course, you can. There are all manner of things buried in the paint, held in place by the sweep and swirl of Pollock's line. Here's a coin, a nail, a screw, a comb, and there's the key—the key to what? you wonder.

Inevitably, the thought arises that these "things" have been transformed—"suffered a sea-change"—into this "painting," a painting that

Pollock has implicitly characterized as "rich and strange." Taken together, the elements of the verbal frame, as we have so far established it, can help us begin to understand the exact nature of this transformation. We have moved from the recognizable and the world of the commonplace—nails, coins, and combs—to the virtually unrecognizable and "strange" world of the painting itself—and if this painting seems strange to you now, imagine how it must have appeared in 1947. The agent of this change seems, in fact, to be painting—more precisely, the act of painting—which has worked on the elements lying on its "ground" in a manner analogous to the sea, covering them, burying them beneath the sand, uncovering them again. If the gestural sweep of Pollock's line can be defined at all, then perhaps comparing it to the ebb and eddy, the churn and swirl of sea and tempest is as close as one can come. Most important, the title announces that the painting is as much a burial as it is a transformation. Whatever riches it may contain, they lay "full fathom five" below. Nothing in Pollock's entire *oeuvre* (that is, the body of his work) better defines the sense of space one feels before his canvases. One peers deep into this work, and it is dark down below. A few things are visible, hinting at more. But Pollock has buried them forever, beneath the swirl of his paint, and they will never be seen again. Pollock gives you a surface, like the surface of the sea, which you know conceals more than it reveals. He provides you with an unfathomable mystery.

CONSIDERING INFORMATIONAL LABELS ACCOMPANYING THE WORK

Though the Pollock painting in the Museum of Modern Art is not accompanied by any more information than I have already given you, it should not be hard to imagine how more information on the label might help you to come to grips with the painting. A simple citation of the appropriate passage in Shakespeare would be helpful to most people. Many museums do provide this sort of informational label as a matter of course.

Most people spend at least as much time reading informational labels in museums as they do looking at the works of art themselves (and this is not the least reason why *Full Fathom Five* is unburdened by a lengthy text—the Museum of Modern Art is one of the busiest museums in the world, and it must keep "traffic" flowing). If there were a label, however, it might read something like this:

POLLOCK, Jackson. *Full Fathom Five.* 1947. Oil on canvas, with nails, tacks, buttons, key, coins, cigarettes, matches, etc. 50⅞ × 30⅛ in. Gift of Peggy Guggenheim.

This painting is one of the first canvases in which Pollock introduced the "all-over" method for which he is famous. By dripping or pouring his paint from sticks or hardened brushes onto canvas tacked to the floor, he was able to liberate his paintings from any sense of being subjected to the inhibiting constraints of traditional, conscious technique. They seemed to spring, now, from unconscious sources. Pollock's title, then, taken from Ariel's song in Act I of Shakespeare's *The Tempest,* suggests a movement below the surface of things and into the unconscious, into a world where painting is transformed, in Ariel's words, into "something rich and strange."

I have limited myself here to approximately 100 words, pretty much the maximum that the public can readily assimilate from a label accompanying an individual work of art. I could say a great deal more—but the very fact that much more can be said is precisely why, as a writer, you can gain not only a great deal of information from labels such as this, but valuable direction for further research and inquiry as well. When you read (and copy down) the information on a label, almost inevitably you will recognize what other information might be of value to you. Given the label above, you would look up the reference to Shakespeare in order to see if there is, in Ariel's song, anything else that might be of use— and there is, as I have already suggested. You would almost certainly want to look at the paintings Pollock executed in 1946 just before this work—some samples of which are in fact close by in the museum—in order to look at how the "inhibiting constraints of traditional, conscious technique" are evident in these earlier paintings. You might want to know about Pollock's interest in the unconscious, and this information, in turn, would probably lead you both to Pollock's own experiences in psychoanalysis and to the influence on Pollock of the French Surrealists, many of whom arrived in New York in the early 1940s in order to escape the war in Europe. The Surrealists emphasized, in their own art, a kind of composition based on "psychic automatism," the dictation of thought in the absence of all control by reason. You might discover, at this point, that many of these French artists circulated around Peggy Guggenheim, who was married to one of them, and that Pollock exhibited almost exclusively at Peggy Guggenheim's gallery—suddenly the brief citation on the label, "Gift of Peggy Guggenheim," takes on a greater resonance. You might want to read the criticism in order to get a

better idea of precisely what that word "all-over" implies. You might even want to follow the history of Pollock's pouring technique as it developed in subsequent years—especially as it relates to the world of images—or his use of concrete things (combs, nails, and so on), which reemerge in his painting after 1950 but which, in *Full Fathom Five,* seem at the brink of completely disappearing beneath the surface of the paint. There seems to be, in other words, an interesting tension, or dialectic, in Pollock's painting between what he calls "pure painting," on the one hand, and reference to the real world, on the other. The relation between the two might be worth exploring. Again, in the Museum of Modern Art there are examples not only of paintings from 1947 to 1950 in which all reference to the world at large seems to have disappeared, but also of later paintings in which recognizable images, even a portrait, reassert themselves.

This is all to suggest that a very substantial essay might easily be developed out of a careful examination of a painting like *Full Fathom Five* and that the conception of this essay would be greatly facilitated by paying attention to the relatively few words that surround the painting as a verbal frame. They are meant to help and inform you. Take advantage of them.

CONSULTING ARTISTS' STATEMENTS AND EXHIBITION CATALOGUES

Very often, especially in one-person exhibitions, an artist's statement, sometimes accompanied by a *curriculum vita* or brief resume of previous exhibitions and writings about the artist's work, will be available, either in leaflet form or prominently displayed as part of the exhibition. The quality of artists' statements varies widely; one sometimes feels that, asked by a curator or gallery director to provide something of the kind, and feeling, as Pollock did, that the work should stand on its own, or that language betrays it, or perhaps out of sheer lack of verbal skill, the artist misrepresents what is going on in the art, intentionally or otherwise. In other words, artists' statements must be approached with caution. However, if they seem to help your analysis of the work, then by all means consider them.

A short statement by Pollock will serve as an example. These comments did not actually accompany an exhibition but were published in a

small magazine called *Possibilities* in 1947. Pollock almost certainly considered them to be an "explanation" of what he was up to in his painting, and almost every critic who has come to grips with his art since has relied on them, perhaps because there is so little else to rely on. They have, at any rate, become so central to our understanding of his work that if a one-person retrospective of Pollock's painting were to be mounted today, the statement would almost surely be printed prominently in the exhibition space itself:

> When I am *in* my painting, I'm not aware of what I'm doing. It is only after a sort of "get acquainted" period that I see what I have been about. I have no fears about making changes, destroying the image, etc., because the painting has a life of its own. I try to let it come through. It is only when I lose contact with the painting that the result is a mess. Otherwise, there is pure harmony, an easy give and take, and the painting comes out well.[2]

The famous first sentence—"When I am *in* my painting, I'm not aware of what I'm doing"—refers to Pollock's insistence on his painting's attachment to the unconscious. The most useful phrase here, however, occurs at the end. What Pollock does in this statement is provide you with a vocabulary that you can use to describe his painting—"pure harmony" and "easy give and take." These are things he wants to achieve, and you need to examine the work itself in order to decide for yourself in what ways an "easy give and take" or a "pure harmony" seems to be in evidence. You might argue, for instance, that the tension between the world of things and the world of "pure painting" is embodied in the "give and take" of line as it begins to delineate form or shape and then flies off free. Or you might say that, because Pollock's surface seems to be uniform in intensity, he achieves a sense of "pure harmony." In other words, this vocabulary gives you a way in, something to look for. It helps you to articulate what you see.

The catalogs that sometimes accompany exhibitions can be of even greater help. Even if all the catalog provides you with is reproductions of the works that interest you most, it can be an invaluable aid in writing your essay, a ready reference once you go home. Be sure, however, that the color in the reproductions is accurate: Compare them with the works themselves (don't trust your memory of the color), and if the reproductions are in black and white, not the actual colors separately. Often the catalog will contain essays to help you understand the exhibition in general as well as individual works. When you are writing about works of

art that are accompanied by such a catalog, it is best to read the essays *after* your first visit and *after* you have begun to form opinions of your own. Even though the essays are usually written by leading experts, you need not necessarily consider them the absolute last word on the works. The best writing about art—and this is as true of professional writing as it is of student writing—raises as many questions as it answers. You should approach catalog essays in the spirit of initiating a dialogue with them. Let them suggest things to you, let them initiate a line of thought for you to follow that you might not have pursued without their lead, but do not let them have the final word. *Use* the essays, certainly, but to support your *own* thinking.

DISCOVERING OTHER HELPFUL MATERIAL IN THE LIBRARY AND ON-LINE

One of the most useful things about exhibition catalogs is that they often contain bibliographies of what has been written about a given artist's work. (The *curriculum vita* of the artist at a one-person show will often contain a bibliography as well.) If you are writing a major research paper on a relatively well-known artist, the best way to begin is to consult the most recent catalog you can find and to compile as current a bibliography as possible.

The preceding sentence contains two notions about the best ways to begin writing about art that have been implicit assumptions of this text from the outset. First, it is important, especially in the initial stages of writing about art, to begin in the particular. It is far easier to write a paper on *Full Fathom Five* than it is on Jackson Pollock—let alone some even larger topic like "American Abstract Painting, 1940 to the Present." A well-reasoned essay on the particular painting would inevitably lead you to some interesting conclusions about Pollock and about American abstract painting as well.

Second, I have assumed that you do not always have to write a major "research" paper, that much of your writing about art, from essays on examinations to more formal assignments, will depend more on simply your ability to ask the right questions about works of art. Inevitably, these simpler writings should lead you to a situation where a larger, more ambitious paper might be not merely possible but something you actually want to do. Still, it may not be necessary to consult secondary sources in the library in order to write a good paper about

very contemporary or relatively unknown work. If the work refers directly to something you don't know—Shakespeare, say, or a Greek myth—you will have to do a little independent research. But many intelligent papers have been written about art without their authors consulting any sources outside the immediate context of the work itself—its title and label, an accompanying artist's statement, and so on. On the other hand, when you are writing about a relatively well-known work of art or artist, your approach might well benefit from a consideration of the opinions of the larger, well-informed community of scholars and critics. At its best, scholarship in art history can help you to understand the work more fully than you might have without it. At the very least, it should help you to frame the questions with which you will engage the work on your own.

If a major research effort is the order of the day, there are some ways to proceed that will save you time and result in a better paper. If you have the opportunity to write about works of art you can see in person, by all means do so. If you are working from the "museum without walls" (much more likely if you are writing a research paper), if at all possible choose to focus your discussion on one or two particular works. If you must write about some larger topic—if, for instance, you have been asked to write about "a major issue in nineteenth-century art"— then approach the problem *through* three or four particular paintings. In other words, find works that seem to embody in some way the problem at hand and draw your larger conclusions from a detailed examination of them. There are many advantages to working this way, some of which will be discussed later, but it should be clear that your conclusions will be far more defensible—and seem more sensible—to a reader who has watched you fashion them out of your detailed analysis of particular works.

Research On-Line

Increasingly, the Internet is revolutionizing the ways in which research and writing are conducted and disseminated. Unless you attend a university with a major research library, probably more information is available to you on-line than in the library itself. And no matter where you go to school, more *current* information is available on-line than in print. So thoroughly is the Internet transforming the landscape of information, in fact, that the library, as an institution, is itself being transformed. No longer is the library the "storehouse" of information; it is,

rather, a center of access, like the Internet itself, a doorway through which information passes.

By 1997 three-quarters of the students in the United States were using the Internet to investigate and explore topics of interest and to gather information for research papers.[3] This said, the World Wide Web can be a frustrating place in which to work. So much information is available that unless you are familiar with the best strategies for accessing information, you can easily find yourself mindlessly "surfing" the Web.

Whatever your Web Browser—at this writing, the two most common are Netscape Navigator and Internet Explorer—you will want to begin by selecting a keyword search engine to help you explore materials available on the Web. As mentioned in Chapter 1, in the discussion of "the museum without walls," two search engines, WebCrawler (**www.webcrawler.com**) and Yahoo! (**www.yahoo.com**), offer directories dedicated to Art. More detailed searches can be conducted on AltaVista (**www.altavista.digital.com**), a very fast search engine that not only searches titles but also looks through the texts of documents for relevant material.

Sometimes you will get lucky. For instance, if you wanted to write on Isamu Noguchi, you would, in each of the three search engines above, almost immediately locate the Web site of the Isamu Noguchi Garden Museum, an exemplary site designed by Media Farm (**www.noguchi.org**). Not only does the site contain a large quantity of superior reproductions of Noguchi's work, in all categories including, biomorphic, geometric, stoneworks, portrait heads, paper works, and so on, it contains a collection of his writings, a complete bibliography of works by him and about him, an exhibition history, and two separate biographical surveys, one connecting him to specific times and places he worked, the other to the people with whom he worked. In addition, the Garden Museum site is linked to other relevant sites, including the Noguchi-designed sculpture garden at the Museum of Fine Arts, Houston. There is no better place than such a site to begin your research.

More often, you will not be so successful in your search. Suppose you wanted to write about Francisco Goya's 1800 portrait of the *Countess of Chinchón* (Fig. 29). If you were to search in AltaVista under the heading "portraits," over one million items would be returned—an impossibly large number. Even the keyword "Goya" results in 9304 items. You will need to combine keywords by using "and" (or +, depending on the search engine) to refine the search. When we thus narrow the scope of the search by combining "Goya and Chinchón," we get 220 returns.

Narrowing the search even further (since "Chinchón" is also a place name), to "Goya and Countess and Chinchón," we get 19 returns, an entirely manageable number.

As it turns out, most of these citations are to other paintings of the Countess by Goya (he painted her four times, twice as a child). And several are entirely unrelated (search engines are not perfect). In this case, AltaVista has scanned a publisher's site that reprints the first chapter of a book on the history of medications. It turns out, we read in the text, that an entirely different Countess of Chinchón, a century and a half earlier, married to the Spanish viceroy of Peru, was stricken with malaria, given tree bark to eat by a native Peruvian heeler, and cured. The bark contained quinine. Thus, the tree, subsequently cultivated to produce quinine, was named the cinchon tree (misspelled, however). As interesting as this is, it has nothing to do with the object of our search.

Remember that different search engines catalog different items, and what one lists might or might not be listed in another. Thus, a Spanish language site on Goya and the family of the Infante Don Luis (the Countess of Chinchón was his eldest daughter) turns up immediately in Yahoo! under the heading Art Masters, subheading Goya, and Web-Crawler features a color survey of Goya's art. But remember, the Internet is constantly in flux. Hundreds, even thousands of new sites are added daily, just as hundreds disappear. Bookmark or Hotlist relevant sites, since search engines constantly modify their lists, and what you found today, you may not be able to find tomorrow. Even better, download information from good sites (being sure to note information you will need for documentation, as discussed at the end of this chapter), since the next time you want to access a site, it may have disappeared altogether.

The Goya search is instructive, because it produced very little that would help to make for a good research paper. At best, the sites discovered provided good color reproductions of the work, and a longer Spanish-language essay. Much research remains to be done, and most of it requires the use of the library and databases.

Using the Library Catalog and Databases

If in your research on the Web you were lucky enough to locate a bibliography, or if, in visiting a museum, you located one in a catalog or artist's statement with a bibliography, begin your research by locating

discussions of the one or two works you have chosen to consider in detail in books or journals at the library. If you were writing on Goya's portrait of the Countess Chinchón, for instance, it would take very little time for you to check the various books on Goya in your library for references to the painting. Your library's catalog is probably on-line. Simply search "Goya, Francisco." If you have trouble locating material, that may be because you have focused your subject too narrowly; for instance, *"Countess Chinchón"* would not have a separate entry or subject heading. If for any reason you have difficulty with a particular search, ask the reference librarian, who will help you locate the subject area heading where you have the best chance of discovering appropriate material. A word of warning: The more contemporary your subject matter, the less likely it is that you will find reference to it in the card catalog. You will have to work from magazines and journals.

If you have access to your library's stacks, you will notice that most of the books on a particular subject have the same general call numbers—usually, two or three related groups. This is because so many books in the art section of the library are grouped in the stacks first by medium, then as sub-groups, by nationality, and, finally, within each country, by artist. (If you write very many papers, you will soon get to know which shelves contain what books. You will know where French or American painting is, where the sculpture books are, and so on.)

Once you have gathered the basic books on your subject, check their indices for reference to particular works you want to discuss. If the discussions seem useful or significant, then read them in more detail. Also look at the footnotes to the passages that discuss the works. These might lead you to other important discussions. If a book contains no specific reference to the works in question (some books are badly indexed, and many catalogs are not indexed at all), scan tables of contents and lists of illustrations: Does the book sound interesting anyway? Consider who published the books—a major art book publisher, a university press, a major museum? All of these are some indication of quality. Finally, consider how recently the book was published. The most recent publications will often incorporate and build upon previous scholarship. You can often avoid plowing through much earlier material by reading discussions of it in later publications. If the earlier work seems interesting and important, by all means return to it, but sometimes it will seem, in the light of more recent scholarship, antiquated or irrelevant.

After you have some general notion of how much material there is on the works of art you've chosen to concentrate on and after you've gotten some sense of the parameters of the critical discussion surrounding

them, consult the *Art Index,* BHA (Bibliography of the History of Art), *Répertoire d'art, RILA (Répertoire international de la littérature de l'art),* or all four. These are basic research tools with which all art students need to be acquainted. They are housed in the reference area of your library. The *Art Index* and BHA are available on-line, and many libraries no longer subscribe to the print editions of the databases (in fact, there is some question whether print editions will continue to exist).

The *Art Index* is a year-by-year bibliography, organized alphabetically by subject matter, of the major art journals and magazines. If you were writing on a painting by Jackson Pollock, you would look up "Pollock, Jackson," and there you would find all the articles and essays written about him in the current year back to 1984 (entries before 1984 have yet to be incorporated in the database). Begin at the top of the list, the most current material, and work your way down. If there is a lot of writing on your particular subject, then five years ought to be sufficient. If there is very little, you may want to go back for ten years. Just as more recent books tend to incorporate and build upon older scholarship, so do more recent essays in the art journals and magazines. Any important older scholarship will almost certainly be mentioned in the more recent essays.

The *Art Index* offers another important feature. Besides listing each article and essay and giving you some idea of the reproductions accompanying each, it lists by title reproductions of individual works by each artist: What is especially useful is that it also includes reproductions appearing in gallery advertisements and the like. If you are having trouble locating a color reproduction of a work that you've seen only in black and white, you can generally find a color reproduction—if one in fact exists—by patiently working your way back through the *Art Index* year by year. Don't forget to check the World Wide Web as well. Recently a distance education student told me that she was able to locate fully 80 percent of the works of art I discussed in ten weeks of lectures on-line (that's something over 300 images).

The *BHA (Bibliography of the History of Art)* was inaugurated in 1991, merging the *Répertoire d'art* and *RILA*. These indexes have the disadvantage of covering only post-Classical Western art—*RILA* covers art since the fourth century and *Répertoire d'art* begins with early Christian art. They exclude non-Western art. The coverage of journals and periodicals in these indexes is, however, sweeping. The *Art Index* catalogs work appearing in about 250 journals, *Répertoire d'art* 1750 journals, many of them European. In addition, *BHA* covers books and offers abstracts of all listed materials (an abstract is a summary of the

argument of the book or article, not an evaluation of it). These abstracts can be especially useful if your library doesn't subscribe to a given journal or own a particular book. Reading the *BHA* or *RILA* abstract can help you determine how important the material might be to your argument and whether you need to recall it or order it through interlibrary loan.

If you are writing about modern art, you should also consult *ARTbibliographies MODERN,* which since 1989 has limited its coverage to art since 1900, but which covers art since 1800 in earlier years. It provides abstracts of not only books and articles, but also exhibition catalogs. Entries since 1974 are available on-line.

If you are writing about architecture, you should consult the *Architectural Index* as well as the *Avery Index to Architectural Periodicals,* which is also available on-line. The *Art Index* also lists architects and major architectural works.

No index can ever be completely up-to-date. In print formats, it generally takes at least a couple of years to put together a single volume. Typically, in 1997, you might expect to find indexes covering materials up through 1995, but nothing more recent. The arrival of on-line databases has diminished the lag-time considerably. But if you need absolutely current material, there is only one thing you can do. You will, at some point late in your research, have a good idea of which journals and magazines show the most interest in your particular subject matter. If you go through the most recent issues of these publications, often you will discover an important piece of recent scholarship.

Using Art Dictionaries and Other Guides

Many times, when you write a more sophisticated paper involving research, you will run across technical vocabulary with which you are unfamiliar. This happens even to the most highly trained art historians and critics. By all means, take the time to look things up you don't know. Your paper will almost always benefit from the extra effort. Ralph Mayer's *Dictionary of Art Terms and Techniques* is an inexpensive paperback reference that is a useful addition to any library. More specialized and complete, the *Adeline Art Dictionary* is an extremely useful summary of specialized terms used in the various fine arts media. It will be housed in the reference section of your library. If you find you need help with terms or concepts that do not appear in *Adeline,* ask your reference librarian.

In 1996, the 34-volume *Dictionary of Art,* edited by Jane Turner, was published by Macmillan. A fifteen-year undertaking, with over 45,000 entries, authored by 6700 scholars from around the world, it is the most inclusive and exhaustive work of its kind. Only film is excluded from its coverage. It includes nearly 20,000 biographies, solid coverage of traditionally neglected areas (photography, architecture, the decorative arts, and the art of non-Western peoples), and articles on media, techniques, and schools or groups.

Another useful reference work is James Hall's *Dictionary of Subjects and Symbols in Art,* a guide to classical mythology and religious themes in Western art. If, for instance, you were writing about Carlo Crivelli's *Crucifixion* (Fig. 10), you might want to know if there were any special significance to the skull at the foot of the cross. Looking up "skull" in Hall's *Dictionary,* you would find that for "a skull at the foot of the cross, see CRUCIFIXION." Turning to "crucifixion," you would discover that "the skull commonly seen at the foot of the cross . . . represents Adam's own skull," and that this skull "sprinkled with the blood that drips from the Saviour's body" is symbolic of the "washing away of Adam's sin."[4] Such information can help you construct a very interesting paper.

Finally, another reference book that is useful to have in your own library and that is available in an inexpensive paperback edition is Peter and Linda Murray's *Dictionary of Art and Artists,* first published in 1959 and revised many times since. It includes short biographies of over 1200 Western artists.

CONSIDERING THE WORK'S HISTORICAL AND CULTURAL CONTEXT

The largest verbal frame surrounding a work of art—larger even than the body of critical and art historical discussions about it—has to do with its place in the larger scheme of things, art historical and otherwise. Each work is conceived in a particular time and in a particular place, and to some degree it is bound to reflect the circumstances of its conception. Cubism, for instance, developed in Paris between 1907 and 1912 as a group style that defined itself not only in relation to much of the painting that had preceded it—Cézanne's late paintings of Mont Sainte-Victoire were exhibited in 1907 after his death and were very influential—but also in the context of a rapidly developing and changing social milieu. Between 1890 and the outbreak of World War I in

August 1914, the pace of European life was dramatically accelerated, its continuities were disrupted, and its long-held truths undermined. Internal combustion and diesel engines began to power the machines that transported people not only long distances but to their very jobs. Electricity replaced gas light in the streets, and these streets were no longer filled with horses and carriages but, suddenly, with automobiles. In 1900, there were 3,000 automobiles in all of France, but by 1907 that number had jumped to 30,000 and by 1913 France was itself *producing* 45,000 automobiles a year. Henry Adams, visiting the 1900 World's Fair in Paris, looked out across the complex of electric dynamos that powered the Fair, and could only feel that "the planet itself seemed less impressive, in its old-fashioned, deliberate, annual or daily revolution, than this huge wheel, revolving within arm's-length at some vertiginous speed." He found himself, he said, "lying in the Gallery of Machines at the Great Exposition of 1900, with [my] historical neck broken by the sudden irruption of forces totally new."[5] Soon airplanes and zeppelins floated across the Parisian skies. In offices, which a generation earlier had been the realm of scriveners and copyists, the routine of day-to-day business was transformed by the telephone, the typewriter, and the tape recorder. The daily newspaper became an institution. Cinemas began to spring up everywhere. In 1905 Einstein published his Special Theory of Relativity, and soon Bohr offered a new model of the atom. As Robert Wohl has put it in an essay on the generation of 1914: "Everything was in flux. Old systems of reference were under attack, old hierarchies were being challenged, and old elites were being pressed to make concessions. Revolution seemed inevitable and those who had something to lose did not conceal their fear."[6] As a style of art, Cubism seemed to embody this upheaval. It reflected, that is, the rapid change and, above all, the "revolutionary" drift of the twentieth century itself. If it was not received with universal enthusiasm, that is because, symbolically at least, it represented the end of one era and the dawn of a new, uncertain future.

The same sorts of context could be, and have been, developed for almost any recognizable period style. Courbet's realism can be usefully tied to the social upheavals in Europe in 1848, and David's neoclassicism to the French Revolution in 1789. The naturalism that marks Giotto's painting in the early fourteenth century, especially noticeable when compared with the flat, almost abstract medieval formulas for representation that are typical of the painting that precedes him, can be said to inaugurate the Renaissance. Above all, Giotto creates *believable* people, who seem to possess highly personal feelings and a sense of

their own individuality. This new "humanism," or interest in the potential and capacity of each individual human being, can be seen throughout Renaissance art, literature, and philosophy.

The more you know about a given period, the more easily you will be able to place whatever works of art you are discussing from that period within a larger context. For this reason, my university requires art history students to take a sequence of courses on the history of Western civilization either before or concurrently with the Survey of Western Art sequence, and I often advise students registering for, say, Nineteenth-Century French Painting to take a course concurrently in nineteenth-century French history or literature.

In the end, however, you will do far better to define, in your paper, the particular qualities that contribute to the power and interest of, for instance, *Full Fathom Five,* than to try to fit *Full Fathom Five* into some preconceived notion of American abstract expressionism or the history of post-World War II American culture. There are, for one thing, widely varying ideas about what, precisely, abstract expressionism even is, let alone how it came to be the most important art movement in the world in the 1950s. One school of thought sees it as a kind of painting interesting only in painting for its own sake—"pure painting," as Pollock himself put it. For them, his greatest paintings are the numbered works of 1947-1950 which have no overt reference. A second group sees abstract expressionism as the record of an event—the painting becomes the record, as it were, of Pollock's physical and mental activity. Still others are interested in the way the idea of representation seems to be contested in the paintings, and this group is especially interested in Pollock's inclusion of more representational elements under layers of paint, as if he is repressing them. This final insight, furthermore, offers those who would like to read Pollock's painting in psychoanalytic terms a way to deal with it from yet another perspective.[7] Which, you ask, is the best approach to *Full Fathom Five?* If you're like me, you're tempted to like something in all of them, but the point is, there are many different approaches to the same work of art, each offering a particular set of insights into the work.

In recent years, some of the most important contributions to our understanding of works of art has come from our increased awareness of their place in **social history.** That is, rather than just considering the formal and stylistic aspects of a work of art, issues such as race, class, gender, and ideology are considered in relation to the work. How, the question is asked, does the work of art reflect broader social patterns of belief and behavior?

Consider, for instance, the *Poem Card* by Koetsu and Sotatsu (Fig. 24). This card, known as a *shikishi* in Japanese, was one of what was probably thirty-six similar cards, each painted by Sotatsu, typically in gold and silver, and then inscribed by Koetsu, who was considered one of the three greatest calligraphers of this day, in verses from a collection of Japanese poetry compiled in 1205 and known as the *Shin kokin wakashu,* or *New Anthology of Ancient and Modern Japanese Verse.* The cards were then pasted on a folding screen, perhaps 14 feet in length, itself decorated with a continuous composition depicting, for instance, a garden or a landscape.

This particular *Poem Card* on the cover dates from about 1606, in the middle of a twenty-year era when the artisans of Kyoto were producing works of calligraphy, painting, ceramic, lacquer, textile, and metalwork in vast quantities. Koetsu was, by profession, a sharpener of swords in Kyoto—actually a position of the highest rank and

Figure 24 Japanese, Hon'ami Koetsu, 1558–1637, and Rawaraya Sotatsu, active 1600–1640, *Poem Card,* 1606, Momoyama-Edo periods. Gold, silver, and ink on paper, height 7⅛ in. © The Cleveland Museum of Art, 1998, John L. Severance Fund, 1987.60.

authority in the court—and Sotatsu was proprietor of a painting shop. But it is more precisely in the context of the Japanese tea ceremony, the Way of Tea, that the Koetsu and Sotatsu collaboration can be best understood.

In small tea rooms specifically designed for the purpose and often decorated with calligraphy on hanging scrolls or screens, the guest was invited to leave the concerns of the world behind and enter a timeless world of ease, harmony, and mutual respect. Both Koetsu and Sotatsu were themselves accomplished tea masters. At each tea ceremony, the master would assemble a variety of different objects and utensils used to make tea and also a collection of painting and calligraphy to be contemplated by both host and guest. In selecting and bringing together different things for each ceremony, in precisely the manner that word and image are brought together in the poem card, the master expresses his individual artistic sensibility, a sensibility shared with his guest, so that guest and host essentially collaborate to make the ceremony in which both participate a work of the highest art. The ideal of unity that this *Poem Card* represents can only be understood in the context of the unity achieved in the larger tea ceremony.

When we ask in what ways works of art reflect broader social patterns of belief and behavior, many other questions might arise as well. **Feminist art criticism,** for instance, has been particularly effective at drawing attention to the ways in which Western art has codified and institutionalized the male gaze as the preeminent point of view. This is explicit in Albrecht Dürer's *Draftsman Drawing a Reclining Nude,* from *The Art of Measurement* (Fig. 25), although it may not have seemed so to Dürer. From Dürer's point of view, the object of the artist's study

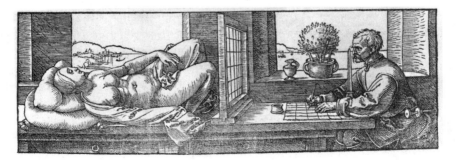

Figure 25 Albrecht Dürer, *Draftsman Drawing a Reclining Nude,* from *The Art of Measurement,* c. 1527. Woodcut, 3 × 8 ½ in. Courtesy, Museum of Fine Arts, Boston, Horatio Greenough Curtis Fund.

presents a formal problem, not a social one. But this is precisely the point: the artist's gaze turns woman into an object—something called, in the classic texts, "form." The grid through which he views her does not just allow him to draw her accurately—his eye suspended over a strikingly phallic obelisk—but it allows him to "master" her. She is nude and vulnerable; he clothed and strong. She passively submits herself to his gaze; his gaze actively controls and dominates her body. She is defined as something to be looked at; he as the centered, focused, subject around whom the world turns.

In other words, one of the strategies of the "masculinist" gaze is to transform the very idea of vision into a question of form. Arguably, Dürer is objectively rendering what he sees before his eyes. In Western art, we tend to privilege vision as the measure of certainty and truth (think, for instance, of the authority eye-witness accounts have in legal disputes). But, as our reading of the Dürer suggests, other truths may be at work in the ostensibly neutral ground that lies between the observer and the observed. I have, for instance, read Georgia O'Keeffe's charcoal drawing *Alligator Pears in a Basket* (Fig. 13) as a study in light and dark—in other words, in purely formal terms. By not recognizing in the work another, more female content—the basket can be seen as a metaphor for the womb, containing and holding its ripening fruit—it could be argued that I have subjected it to precisely this male gaze. Similarly, I have ignored the apparent weakness of the male figure in Käthe Kollwitz's *The Downtrodden* (Fig. 14), and I have seen in Picasso's *Woman with Book,* reproduced on the back cover, a harmony of colors where perhaps I ought to recognize their dissonance, a loving gaze where perhaps it is better to feel a more threatening force. As Arianna Stassinopoulos Huffington reminds us in her biography *Picasso: Creator and Destroyer:* "What seemed a life guided by burning passions—for painting, for women, for ideas—seemed a moment later the story of a man unable to love, intent on seduction not in the search for love, not even in the desire to possess, but in a compulsion to destroy."[8] In Huffington's view, the figure in the mirror behind Marie-Thérèse becomes more ominous. The point is a simple one: The feminist perspective offers exciting possibilities for us to re-see and reinterpret works of art.

The male gaze proscribed in feminist criticism is the same gaze that colonized the world in the eighteenth and nineteenth centuries—the "master's gaze," which oppressed people of color, asserted the ascendency of Western civilization, and, at best, viewed people unlike itself as the exotic Other. The dominant identity—and in some sense, therefore, the *only* identity, since it was the only one that was *recognized*—

was white, Western, and male. Since the late 1980s, other identities have increasingly asserted themselves in the art world, so much so that many view the art world today as a vast, multicultural laboratory in which questions of power, domination, and control are examined in terms of cultural representation. Questions of ethnicity and race, gender, sexual preference, class, and, increasingly, urban/rural values, are all addressed in works of art that ultimately raise the question of "identity politics." Carrie Mae Weems's *Coffee Pot* (Fig. 2) is a case in point. The work underscores the problematic way in which ethnic identity is constructed, how marginalized people define themselves in relation to the center, and just how pervasive the power of the center really is.

Examining the cultural and historical context of art offers some of the most exciting possibilities for writing about art. Bring your other coursework in the university to bear on what you study in art history. Think about the ways in which your history course, or your sociology course, might inform the artworks you see. Such perspectives can only challenge your own assumptions about the work of art, and every time you challenge an assumption, greater understanding is the only result.

QUOTING AND DOCUMENTING YOUR SOURCES

Learning the Art of Quoting

The greatest danger that students confront when they write research papers is that their final paper will contain, in the end, nothing of their own but will be a compendium of appropriate quotations. This is as true, incidentally, of doctoral students as it is first-year undergraduates. Many a doctoral thesis is overburdened by references. It is a failing that is easy to understand: Why speak for yourself when so many people more informed than yourself can speak for you? And besides, you want the professor to see how much research you've done. Remember, however, that it is *your* mind that the professor wants to see at work, not that of some famous critic.

Here is a rule of thumb for fitting quotations into your own writing: *When you quote, always move on from the quotation and continue the paragraph by developing the idea the quotation initiates.*

Earlier in this chapter it was suggested that you approach critical essays in the spirit of initiating a dialogue with them. By forcing yourself to

respond to the material you quote, you will in fact begin just such a dialogue. You will never become a slave to your research. Also, in a very real sense, by responding to it and developing it further, you will make the quoted material your own. It becomes part of your argument, not something outside your argument to which you have deferred.

In other words, there is a real art to quoting. You want to quote things that are especially informative or well written. Such material tends to elevate the quality of your own prose. As in playing tennis, you tend to play to the level of your opposition; this is not to say, however, that you should quote only opinions with which you can argue. Some of the best passages in papers are those in which something is said well in a quotation and then the student, in the particular context of the argument at hand, says it better. Perhaps you have noticed that in this book other critics have been quoted precisely in this way. Joshua Taylor's discussion of the Perugino and Crivelli crucifixions cited in Chapter 2 is a classic piece of art historical writing. I have tried to elevate my own discussion by incorporating Taylor's argument into my own, but I built on Taylor's distinctions, and I used them to my own ends. The discussion of Perugino and Crivelli was developed, in fact, to provide you with a model for quoting authoritative sources. Refer to it when you want to quote secondary sources (and be sure to note that the quotation furthers an argument that continues after the quotation itself). Refer also to the technical discussions of quotation and ellipses, in Sections 14 and 15 of the Appendix. Good writing tends to stimulate more good writing. When you read criticism, look not only for useful information but also for the well-turned phrase, the interesting and informative anecdote, the particularly insightful analysis of a work of art. These things can do more than inform you, they can provide a foundation upon which to build your own essay.

Acknowledging Your Sources

I am constantly surprised at the number of students who seem to be embarrassed that they have consulted research materials. To the contrary, doing so shows energy, interest, and determination. The only times you need to worry about using such materials—except when the professor, for whatever reason, asks you not to consult secondary sources—is when you have done a superficial job, consulting only one or two books or articles and, more important, when you have not acknowledged that you have

done so. If you do research, do it well. If you appropriate phrases, whole passages, ideas—even if you've put these in your own words—or the logic of an argument from someone else, and you fail to acknowledge it, then you have plagiarized the work. The penalties for plagiarism vary from school to school, but they are never very pleasant.

If you use research materials well—as the beginning of your argument, not as an end in themselves—then you need never be embarrassed to cite these materials. In fact, one of the checks you can use to judge the quality of your own paper is to determine at the draft stage just how much *you* there is in the paper. If you detect more of your absence from the argument than your presence, if you feel that one solution might be to go back and convert some quotations into your own words, then you have probably not entered into a dialogue with the criticism so much as let the criticism rule you. To revise, engage the criticism. See if you can push its ideas further, perhaps by using it to analyze a particular work, a work with which it hasn't dealt.

You do not need to footnote or acknowledge anything that could be considered common knowledge—dates of birth and death, the location of paintings, historical facts, the definitions of words, and so on. Generally, if a question of interpretation seems to enter into the material, or if the fact seems genuinely new, then by all means cite your source. When in doubt, play it safe. But again, watch for overcitation. If you consistently have more than two or three footnotes per typed page, then something is wrong—either you are acknowledging things you need not acknowledge or your argument is too dependent on outside sources.

Choosing Your Footnote Style

Footnote conventions in art history differ widely, and as you read you will encounter many different styles. They depend, among other things, on where the article or book you are reading was published. The British have one system; the Americans another. Even in the United States, conventions differ from publication to publication: *Art in America* has its own ideas about what a footnote should look like, while the *Art Bulletin* has a completely different set of standards.

The footnotes that have been used in this book (pp. 126-27) should give you an idea of the style suggested by *The Chicago Manual of Style,* a style preferred by many book publishers. In all styles, however, a few general rules apply. Generally, in order to designate a footnote, simply

put a raised number after the final punctuation of the sentence, unless there are several references in a single sentence (something you should work to avoid), or unless clarity demands that you footnote a single phrase in an otherwise complex sentence (something else that you can probably avoid). Number the notes consecutively and, if you are typing, put them at the end of the paper (it is simply too difficult to put footnotes at the bottom of the page if you are typing). If you are using a word processor, you can probably choose whether to put them at the end of the paper or at the bottom of the page. Some people prefer notes at the bottom of the page, some at the back of the paper. Ask your professor. However, if you put your footnotes at the end of the paper, do *not* staple the pages together, since the professor will probably want to remove them and consult them while reading the paper. Many people prefer that notes be double-spaced to facilitate reading and corrections. Again, ask about this.

Each footnote citation is, in effect, a one-sentence paragraph. Indent, type the number, and then type the footnote. It will begin with a capital letter and end with a period. Outlined below are two alternative styles for your consideration.

The Chicago Style. Briefly, for citations of a **book,** the Chicago Style form is the following:

1. Author(s), *Title* (Place of publication: Publisher, date of publication), page numbers.

The author's name appears in its normal sequence—given name, initials, and surname—followed by a comma. The title is italicized, or underlined to indicate italics if you do not have access to italic type. There is no punctuation between the title and the parentheses (never place a comma before parentheses, in footnotes or otherwise), but a comma follows the parenthetical information. Finally, the page numbers are listed, without the abbreviations "p." or "pp." The note ends with a period. Thus, if you were to refer to these two pages in this book, your note, following the style outlined above, would look like this:

1. Henry M. Sayre, *Writing about Art* (Upper Saddle River, NJ: Prentice Hall, 1999), 80-81.

If there is an **editor** or **translator** to the edition you are using, follow the title with a comma and place that information before the parenthetical

information, again followed by no punctuation, as in the fifth note to Chapter 1 in this book:

> 5. André Malraux, *Museum Without Walls,* trans. Stuart Gilbert and Francis Price (London: Secker & Warburg, 1967), 11-12.

The abbreviation "trans." is usually employed for "translated by," and "ed." for "edited by."

There are two special instances of citation that often come up in writing about art. Sometimes you will be quoting from a recent edition of a classic text, but it will seem important, for clarity's sake, that you acknowledge in the note the original publication date of the text. Perhaps you are writing about art history in the 1950s, and you cite Kenneth Clark's 1953 Mellon Lectures on the nude, first published in 1956, but the edition you are using was published by Princeton University Press in the 1970s. Use the following form:

> 2. Kenneth Clark, *The Nude: A Study in Ideal Form* (1956; rpt. Princeton, NJ: Princeton University Press, 1972), 56.

Here, the abbreviation "rpt." means "reprinted by." The second special case involves secondhand references. You want to quote material that you have discovered not in the original work but quoted by someone else. In this case, use a double citation:

> 3. Henri Matisse, *Jazz* (Paris: Verve, 1947), unpaginated; quoted in John Elderfield, *Henri Matisse: A Retrospective* (New York: Museum of Modern Art, 1992), 23.

Here, the first part of the citation is separated from the second half by a semicolon. If you are quoting from text that does not give you any information about the source of the original, you may want to begin your citation with the phrase "Quoted in."

In order to refer to an article or essay in a **journal** or **magazine,** use this form:

> 4. Author(s), "Title of Article," *Name of Journal* Vol # (Date of publication): page number(s).

An essay that is included in an **anthology** of essays begins in the same way, but then is treated like a book:

5. Author(s), "Title of Essay," *Name of Anthology,* ed. Name of editor (Place of publication: Publisher, date of publication), page number(s).

In both cases, the title of the article or essay is in quotation marks and the name of the journal or book is italicized (or underlined to indicate italics if you are typing). In the case of the article in a journal or magazine, there is no punctuation either between the journal name and the volume number or between the volume number and the date of publication (except the parenthesis). The date of publication is put in parentheses and is followed by a colon. The page numbers, again, are not introduced by "p." or "pp." If there are no page numbers, as there often are not in art publications, simply put "unpaginated." The following is an example from the footnotes at the back of this book:

3. Brian O'Doherty, "Inside the White Cube: Notes on the Gallery Space," *Artforum* 14 (March 1976): 24-25.

When you make **subsequent references** to a work you've already cited in full, you may shorten your note. For instance, a subsequent reference to the article above might look like this:

7. O'Doherty, 27.

If there were more than one article by O'Doherty cited in your text, you would lengthen the note in order to avoid confusion:

7. O'Doherty, "Inside the White Cube," 27.

When the note refers to exactly the same citation as the one that precedes it, it is still permissible to use the Latin abbreviation "Ibid., short for *ibidem,* "in the same place." I actually prefer it, since it is perfectly clear, and shortens the notes. For instance, if note 8 were also to O'Doherty's "Inside the White Cube," and to the same page, your note would be:

8. Ibid.

If it were to a different page, however, it would be:

8. Ibid., 29.

If you do a lot of writing, you might want to purchase the *Chicago Manual* (more than just a footnote guide, it is a complete guide to style

and usage), but the reference desk in almost every library will have a copy of it. For difficult footnote problems, consult it. Almost every imaginable contingency is anticipated.

The Art Bulletin Style. A second possible footnote style is that of the *Art Bulletin,* among the most prestigious of the art history journals. It differs considerably from the Chicago Style. It is what as known as a "short form" method of citation (the full references will appear in your bibliography). Any citation of a text that is referred to frequently in the essay consists only of the author's surname and the page number, separated by a comma, even in the first citation (in this case, imagine I am citing Linda Nochlin's *Realism*):

 1. Nochlin, 243.

If there are two or more books by Nochlin cited in your text, they are distinguished by a short abbreviation of the title, and Nochlin's full name is included to the abbreviated title from an initial:

 1. Linda Nochlin, R, 243. (R is for *Realism.*)

 2. Linda Nochlin, WAP, 15. (WAP is for *Women, Art, and Power.*)

Two or more articles by the same author are cited by name and year of publication (the full references will appear in your bibliography):

 1. Hickey, 1997, 60.

 2. Hickey, 1995, 80.

If two or more articles by the author have the same year of publication should be designated by "a," "b," "c," and so on:

 1. Hickey, 1997a, 114.

As in the *Chicago Style,* "Ibid." replaces "Nochlin" if the reference is to the work cited in the immediately preceding note.

Works not cited frequently in the essay employ a more extended footnote form. For books, use the following format:

 2. Henry M. Sayre, *Writing about Art,* Upper Saddle River, NJ, 1999, 77-78.

Notice that this form is an abbreviated version of the Chicago Style. No publisher is listed, and parentheses are not utilized. For articles use the following format:

3. Brian O'Doherty, "Inside the White Cube: Notes on the Gallery Space," *Artforum,* XIV, March 1976, 24-25.

Again no parentheses are utilized. The volume number of the journal is indicated in this format by roman numerals. Second references to infrequently cited sources refer to the first citation:

7. O'Doherty (as in n. 3), 27.

The "short form" may seem far less cumbersome at first glance, but it requires a bibliography of all frequently cited sources at the end of the essay. The citations are listed in alphabetical order by author. Here are representative examples:

Nochlin, Linda, R: Realism, New York, 1971.

———, WAP: *Women, Art, and Power and Other Essays,* New York, 1988.

Hickey, Dave, 1995, "Edward Ruscha: *Twentysix Gasoline Stations, 1962,*" *Artforum,* XXXIII, Summer, 80-81, 126.

———, 1997, "Critical Encounters," *Artforum,* XXXV, January, 60-61.

Notice, in these examples, that the second listing of works by the same author is indicated with an extended underline (five spaces). The abbreviation used for book titles follows the author's name, followed by a colon. In the case of articles, the date has been moved forward after the author's name to help distinguish more quickly between works.

It is useful to keep in mind that footnote styles are not meant to confuse you, though they almost inevitably seem diabolically complicated to most beginning writers. They are meant to be straightforward references for your reader's information and convenience. There is, in the end, a very easy set of principles that can guide you in developing your notes: After the first full citation, be as brief as your sense of clarity will allow, be logical, and be consistent. If you err, err in the direction of providing too much information. If you feel confusion set in, get help from the *Chicago Manual* or consult a recent issue of the *Art Bulletin.*

Citing Internet Sources

Conventions for citing Internet sources are only now being developed, but a few principles are by now clear. As with books and articles, you need to cite author and title if available, and then the URL (Uniform Resource Locator, the unique Internet address of a given document) of the site itself. You also need to site the date you visited the site. Sites on the World Wide Web are subject to constant update and change. As a result, something you cite today may well be gone at a later date, or moved to a different location. Web pages all possess a "last modified" date, which will allow anyone looking for the material in your citation to see if the site has been revised since you visited it.

To cite a document available on the **World Wide Web** utilize the following form:

1. Author(s), "Title of document," *Title of Complete Work,* date of publication <URL> (date of visit).

1. Isamu Noguchi, "On Gardens as Sculpture," *A Sculptor's World,* 1968 <www.noguchi.org/intextall.html> (18 Mar. 1998).

To cite an **e-mail** communication, utilize the following form:

1. Author <author's e-mail address> "subject line from posting," date of publication, type of communication [i.e., personal communication, distribution list, or Listserv address in angle brackets] (date of access).

1. Jackson Flash <jackflash@rock.com> "On Jumping," 16 Feb. 1998, personal communication (19 Feb. 1998).

WRITING ABOUT

ART

4

WORKING WITH WORDS AND IMAGES

The Process of Writing about What You See

You can begin the actual process of writing about a particular work of art in many ways. Once you've chosen what you're going to discuss, once you've looked at it carefully for a while, the point comes when you must put pen to paper—or, as is often the case these days, open a new file in your software—and begin. Many people never fully discover what it is they think until they begin to write. The process of writing in itself can free you to articulate what you think. Being forced to write something down sometimes helps you to make up your mind.

GATHERING TOGETHER WHAT YOU KNOW

The process of writing should begin as early as possible—from the first moment you enter a gallery if that is at all practicable. Jot down your feelings, your initial impressions, which painting or sculpture attracts you. You might even want to note which items seem totally uninteresting. Then give yourself a chance, later, to see if these apparently "uninteresting" works are still with you. If they are, there might be something more to them than you originally thought, something worth

investigating and developing. Above all, don't suppose that you will remember how you felt, that you will be able to recreate the process of choices and decisions that finally leads you to your interest in a particular work. When I review exhibitions or shows, I first quickly tour the gallery or exhibition space, taking notes, diagramming the rooms, noting what intrigues me, what alienates me, and what seems less than important. Depending on the show, I might jot down titles, dates, the names of painters. If I quickly recognize a direction of thought I want to pursue, I'll make notes about that. If I find any exceptional highlights, works around which I sense I could focus a discussion, I'll note those down as well.

Then I leave. I go out to the lobby, or to a restaurant, or to a nearby park bench, and reread my notes. In a short time I have a pretty good sense of what I need to go back to see. I make notes about possible lines of thought to pursue, questions that seem to be raised, works I need to look at more intently. I generally try to ask myself a couple of questions that will force me to consider works I might otherwise ignore. I might even jot down in my notebook—and I have done it—how could anybody (i.e., the curator or the painter or whomever) interested in "x" (which I like) also be interested in "y" (which I don't)? I'll look at all those things I don't like in order to see what, if any, redeeming qualities I can discover in them.

This process doesn't take a very long time. I usually like to make a quick short visit before lunch, followed by a more leisurely and more intense viewing afterwards. I almost always have a good sense of what I want to say, and which works I want to focus my discussion on, within a half hour of my return visit. Then the real work of writing begins.

FOCUSING YOUR DISCUSSION

If you read many discussions about art, you will quickly notice that the most readable and interesting of them almost always focus on particular works. If you go back and look at whatever section of this book has seemed to you the most interesting, you will probably find that it is a particular discussion of a particular work. In other words, I could discuss something like color theory all day on a fairly abstract level, but what makes it interesting, in the end, is van Gogh's particular application of color in *The Night Café* or Picasso's in *Woman with Book*. Similarly, as a writing tactic, for the discussion in the last chapter I tried to

find an interesting example of a work whose title and medium both mattered, Pollock's *Full Fathom Five,* in order to sustain your interest (and in order to be convincing). Consider how dry the previous chapters might have been without particular examples and sometime highly detailed analysis. Then consider how likely you would have been to get much out of them without those examples.

In other words, this art textbook, like many others, is organized by the principle of using extended discussions of particular works to make more general points. When art appreciation or art history professors analyze works of art in class, they are usually providing you with the same sorts of models. Ground your writing in the concrete discussion of particular works. Focus on the specific problems of form, design, and content that they raise. You will almost always discover that in the process of describing and analyzing particular works, you will arrive at more general conclusions that you did not anticipate.

What are the advantages of writing in this way? In the first place, when you begin to write, you do not know precisely where you are going, what your conclusions will be. This approach to writing does run somewhat counter to the rationale of outline making. Outlines have their function—they provide a way for you to organize your ideas and present them in an orderly way—but if you let order supplant inspiration so that you find yourself filling out the skeleton of your outline to the necessary 1000 or 2000 words, then both the process of writing your essay and the essay itself will be boring. Often I can look at a group of student essays and tell who worked from outlines from the outset and who didn't. The giveaway is that in an essay first conceived in outline form, the introduction and the conclusion are almost always virtually the same. A skilled writer will manage to alter the language a little, but the substance will not change. This occurs because, as the writer begins, the essay's conclusions are already predetermined. In contrast, an essay that begins as a process of discovery and exploration almost always ends differently than it begins. It discovers something it didn't anticipate. It articulates connections it could at first only intuit. The second kind of essay is almost always more interesting to read. It seems to be engaged. It seems active, whereas the other kind of essay, no matter how "right" it might be, seems static in comparison.

To outline effectively and avoid being trapped in a predetermined set of assumptions, think of your main and subordinate ideas as opportunities to ask questions. If you were to write about Pollock's *Full Fathom Five,* you might begin your outline like this:

 I. The significance of the title
 A. Reference to Shakespeare
 1. Idea of death
 2. Idea of transformation (i.e., "sea-change")
 B. Relation to technique
 1. All-over effect of canvas (i.e., abstraction)
 2. Submergence of recognizable objects in paint
 II. The idea of surface and depth, etc.

Behind this outline, however, lies a series of questions. How do death and transformation go together? What kind of "death" is evident in the canvas? Does it display the death of "representation," or of the "object"? What has "representation" been "transformed" into? If Pollock has transformed representation (or reference to the world of things) into abstraction, is abstraction a matter of "surface"? If so, does representation still lie hidden in the painting's depths? These questions, of course, are not easy to answer, and though you might have some idea of the direction in which you need to go after having arrived at the outline, the territory remains uncharted and interesting to explore.

 Whether or not you choose to outline beforehand, during the revision process, you can check the logical development of your essay by seeing if you are able to outline your argument. For the many writers who find outlining an overly restrictive way to begin writing, other ways to begin are available. Depending on your temperament, any of the methods described in the next sections, or some combination of them, perhaps even including outlining, might suit you.

Brainstorming and Mapping

 I began to organize this book by brainstorming. In other words, I made a random list of topics and subjects that I thought I should address in a book on writing about art. This is how the list began:

formal elements	indexes
principles of design	footnote form
the museum	the verbal frame
the museum without walls	words and images
the "white cube"	Weems's *Coffee Pot*
Duchamp's urinal	student essays
Joshua Taylor	outlining, prewriting, etc.
titles	revising

For several days I added to this list, and as I did so, certain patterns began to emerge. Some of these patterns were evident from the outset; for instance, a cluster of ideas about museums seemed important right away. Soon the titles of the four chapter headings presented themselves. I began to fill out the list in greater detail, grouping elements as I went. For instance, the phrase "the verbal frame" suggested a group of ideas for more particular development:

the "verbal frame"
} Pollock's *Full Fathom Five*
importance of title
importance of medium

A whole page began to take shape under the heading "formal elements." I listed each formal element separately and jotted down ideas about how I might approach it:

Line
—Taylor on crucifixions
　—use later to talk about quotation (?)
—leads to discussion of space/perspective
　—Monet's *Gare St.-Lazare*

I eventually discarded many ideas that occurred to me. A great many notations, followed by question marks, alerted me to places where I might tie discussions together. Some of these I followed up, some I never did. New ideas and modifications continued to occur to me throughout the writing process. Nevertheless, the essential drift of this book was in place in a matter of a few weeks.

Mapping is a more visual form of this method of planning an essay, one that many art students find particularly appealing. Begin by writing your subject in a circle at the center of a sheet of paper. Draw a line out from the circle and name a major subdivision of your subject. Circle it and move out again from there to further subdivisions. A partial map of the section on the formal elements in this book would look like the chart at the bottom of page 90.

Most of you will not be faced with taking on a project as large as writing a book, but the approaches described above are useful even if you have to write only a short paper. Furthermore, if you find outlining useful, brainstorming and mapping are very good tools for generating your outline. It should be obvious that the material on "Line" above is really an informal outline, the beginnings of the much more formal shape the section of "Line" in this book would eventually take.

Using Formal Description to Begin Writing

Formal description is another useful approach for getting started in writing about art. Two elements comprise a formal description of a work of art: (1) a more or less straightforward description of the recognizable subject matter of the work, and (2) a summary of the various formal elements and principles of design at work in it. When you describe the subject matter of the work, by all means begin by mentioning the *title* and, if the title seems to contribute to your understanding of the subject matter, you will want to suggest what questions the title raises about the work. Like titles of novels and plays, titles of works of art are always italicized, or underlined if you are typing (see the Appendix, section 6). You could refer to Marcel Duchamp's urinal, or you could refer to Duchamp's urinal entitled *Fountain.* The second reference is far more suggestive and will lead, out of the simple accuracy and precision of your description, to a richer understanding of the work. What does it

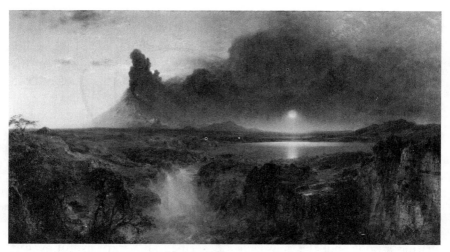

Figure 26 Frederic Edwin Church, *Cotopaxi, Ecuador,* 1862. Oil on canvas, 48 in. × 7 ft. 1 in. © 1987 The Detroit Institute of Arts, Founders Society purchase, Richard A. Manoogian, Robert H. Tannahil Foundation Fund, and Beatrice W. Rogers Fund. Photograph © 1987 The Detroit Institute of Arts.

mean to call a urinal *Fountain?* You don't have to answer the question at this point, but it is important to raise it right away.

Begin your analysis of the formal elements of the work and how they are designed by noting the medium or media in which the work is executed. You would almost certainly see more significance in Pollock's *Full Fathom Five* were you to note its materials from the outset. And while it might not seem relevant to you until you learn more about the Japanese tea ceremony, it is important to know that the Koetsu and Sotatsu *Poem Card* (Fig. 24) is drawn not only in ink, but in gold and silver.

Here is a formal description of Frederic Edwin Church's *Cotopaxi, Ecuador,* painted in 1862 (Fig. 26). The essay was written by an undergraduate student in a survey of nineteenth-century art.

> Frederic Edwin Church's *Cotopaxi, Ecuador* is a large, 48 x 85 inch oil painting of a volcano in eruption in South America. The horizon line cuts the canvas across the center, creating a sense of compositional balance to the scene. In the foreground are cliffs and jagged rocks, a chasm above which the viewer, more or less precariously, stands. This deep ravine, through which a river

covered with mist must flow, leads back to a lake in the right center of the painting. Directly above the lake the sun is setting (or is it rising?). To the left, on the horizon, is Cotopaxi itself, spewing a plume of smoke upward to fill the entire right-hand corner of the canvas. Despite their difference in feel, the fiery volcano on the left is balanced by the bright light reflected in the lake on the right, and that pattern of light forms a cross. The curve of the clouds is repeated in the curve of the water's edge by the rocks, making the sun look, alternately, like the pupil of an ogre's eyeball and the eye of God.

The scene seems simultaneously dangerous and peaceful. Your eye is led up the river, around the lake, through the smoke and always back to a sort of double focus, the bright yellow sun and the volcano, heaven and hell. On the one hand, the sun reflects the stillness of the lake. On the other, it seems closer to the molten energy of the volcano. The smoke, jagged rocks, and molten lava coloring the scene all make you think of the creation of the world. But then again, we may be witnessing the end of the earth, apocalypse. Everywhere there is strong contrast between light and dark. It is as if the forces of light were fighting with the forces of darkness.

In the lower left-hand corner a woman and what looks like a donkey walk through the scene. They are enveloped in the awesomeness of their surroundings. The woman and donkey are so small that it almost seems as if the artist were implying that man is small and insignificant compared to nature itself. The painting is large enough that it reinforces this feeling.

This student has by no means exhausted the formal interest of Church's *Cotopaxi*, but there is evidence of a very thoughtful analysis of the painting, and there is surely a lot of good material here out of which to develop a much more substantial essay. Clearly, the most

important issue that this writer has located is the apparent tension in the painting between light and dark, violence and calm, order and chaos, even heaven and hell, and our relative insignificance before such large and unpredictable forces in the universe.

This essay is, nevertheless, an early draft in which the writer is attempting to explore, through description, what possibilities the painting might hold for further discussion. A great many student papers never get past this stage: They describe the work more or less adequately—or even very well—but nothing more. The challenge now is to go on by asking what it all means. Why has Church created this tension? Or, alternately, why does he insist on balancing opposite forces? Does he merely want to show us our insignificance before Nature, and if so, why? Why the careful division of the canvas into virtually symmetrical units? Is the sun in fact setting, or is it rising? (This is not so slight a question as it might at first appear—the answer dramatically affects the mood of the painting.) These are just a few of the questions that can be raised at this point, and that a good paper will continue to begin at least to answer.

This writer, in fact, did go on to do a great deal of research, and the resulting paper, which is far too long to reproduce here, considered *Cotopaxi* in relation to the writings of Ralph Waldo Emerson and Henry David Thoreau. Comparison was made, for instance, between Emerson's habit of contradicting himself as he sought a larger, more synthetic vision and the sense of "balanced opposition" one feels in the Church painting. Emerson's famous "transparent eyeball" passage, in which Emerson becomes, as he says, "part or parcel of God," becomes complicated, in Church's painting, by a more all-encompassing, larger, and finally less optimistic vision. Like Thoreau on Mt. Ktaadn in Maine, lost in the tortuous jumble of rocks and cliffs, Church recognizes that Nature is not always benign. Compositional balance, the author argued, was no longer employed so much to affect the sense of harmony and order both Emerson and Thoreau would have preferred as to create an almost modern "balance of power." In this light, *Cotopaxi* represents a revision of Emerson, a kind of "pragmatic transcendentalism."

Using Prewriting as a Way to Begin

Some students are more comfortable, at least initially, writing in a looser, somewhat more freewheeling style than the more systematic approach of the formal description. There are no rules in prewriting.

Anything goes. The object, in fact, is to put down on paper as much as you can think of in a relatively limited amount of time. A lot of it you will probably later reject, but usually the basis for your essay can be developed out of this material.

The following is an example of the prewriting from which Amy Harrison, a student in a twentieth-century painting survey, developed an essay on "Two Twentieth-Century Abstract Paintings." She wrote this at the computer in about forty minutes after looking at the two paintings in question, Joan Miró's *Personnages rythmiques* (Fig. 27) and Vasily Kandinsky's *Tempered Elan* (Fig. 28), for fifteen or twenty minutes. Notice that she isn't worried here about the niceties of punctuation, nor is she worried, at this point, about whether she's right or wrong. Her mind is simply wandering, as fast as it can, among the possibilities:

```
Miró uses blocks of color for a background uses
the curve a lot there are mirrored images like the
shape of the moon in the upper right hand corner
and the part of the body of the far left figure
```

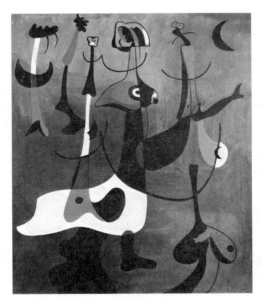

Figure 27 Joan Miró, *Personnages rythmiques,* 1934. Oil on canvas, 6 ft. 4 in. × 5 ft. 7 ⅜ in. Kunstsammlung Nordrhein-Westfalen, Düsseldorf. © 1999 Artists Rights Society (ARS), New York/ADAGP, Paris.

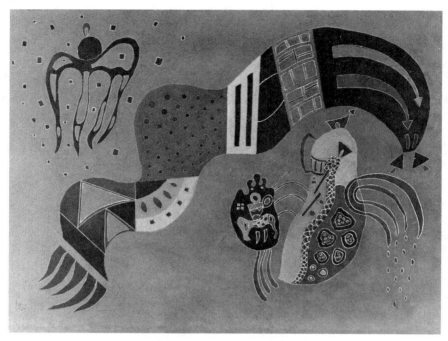

Figure 28 Vasily Kandinsky, *Tempered Elan,* 1944. Oil on cardboard, 16 ½ × 22 ⅞ in. Musée National d'Art Moderne, Centre Georges Pomipdou, Paris. © 1998 Artists Rights Society (ARS), New York/ADAGP, Paris.

the central figure seems to be woman looked at
from different angle her breast shapes are
mirrored in the lower right hand figure. He also
uses solid dots and the moon is mirrored again in
the red and yellow shape there are also repeating
arches that cross other lines. The two arches
that are connected together give a sense of
perspective, depth. The smaller one that's
attached to the skinny figure puts that figure
behind the central one a couple of little faces
one of them looks mad the red and black shape on
the central figure's white body it looks at one
time like two separate things then another time
looks like the black is the underside of the red
and is twisted so we can see it. Lots of contrasts
between black, white, and red one shape in the
left background could be a tree with a leaf on top
get birth images amoebas or other basic life

forms. The central black arch that cuts between the white and black par of the central figure plays tricks on your eyes you see the white part as being separate from the rest jumps away from the other part. The dot on the central figure's breast seems to want to fall off of it the line separating that breast and the other half of the body creates an illusion that the half bullseye is both separate and that the black part blends in with the black breast. The black and white alternating arches with the red at the end also mirror the head that has alternating red and black stripes with a white one on one end. Miró seems to be playing with perspective and illusions created by the eye. Also the shapes seem to be floating about have movement. They are rhythmic personages a dance. There are very few straight lines and where there are they jump out seem misplaced everything unstable growing changing rhythm of life. The alternating color shapes and merely outline shapes give a sense of a game Inside the oval the head of the central figure the red and the black shapes each make a face, their lips meet in a kiss

Kandinsky—full of curved lines which are contrasted with rectangular bars upper left hand corner shape looks like a jellyfish symbolizing primitive life the beginning the other shapes also seem to be like primitive life forms. He also plays with transparent space and colored space especially the transparent jellyfish surrounded by solid square shapes played against light shapes to create perspective the one bright orange bar really jumps out at me looks separate from the thing it's on. The red loop on the top of the jellyfish is mirrored with the half red triangle on top of the lower right hand figure and the one inside the small dark figure has same thing happening with part of that figure as in Miró's painting the rainbow on its right side looks like it's continued out with the arches but the white

```
line also cuts them apart duality the arches also
seem to be taking away the life source of the
shape. Uses both geometric and organic shapes
prevent them from complete freedom the squares
surround the jellyfish, and the orange bar pins
down the tail of the large amoeba form the other
smaller orange bar pokes in the little dark form
and comes out the other side penetrating it. Lots
of play with design more intricate than the Miró
everything has a border to it and is completely
filled or completely empty no oozing like in the
Miró less movement more static than Miró The clear
space between the two dark brown sections of the
central figure really stands out especially with
its bright red borders He seems to want to keep
life somehow in the picture even when just playing
with design and color The dark brown circle on top
of the jellyfish is like Miró's black dots He
incorporates color, line, and object A movement
toward an abstract design that's for itself but at
the same time leaves room for the imagination to
see something recognizable in the painting painting
for the artist's sake but not forgetting the viewer
```

Perhaps the most interesting thing that happens in this exercise is that, although the author begins by analyzing each painting separately, by the end of the section on Kandinsky she has begun to compare the two works. I think this is almost inevitable. What has happened is that after looking hard at the Miró she sees the Kandinsky in light of it. In some ways, this approach distorts the Kandinsky—it wasn't painted, after all, to be seen in the context of the Miró—but it also helps the author recognize some of the special characteristics of both paintings. In particular, "static" is not a word that one would normally think of when confronted by the Kandinsky, but next to the Miró it *is* comparatively static. This comparative stasis eventually led the author to make an important distinction between Miró's "fluid" abstraction and Kandinsky's "frozen" forms.

On-Line Writing

Pre-writing has much in common with the kinds of on-line writing that most students engage in—that is, e-mail and Listserv environments.

The difference is that in on-line environments, the fluidity of thought that pre-writing generates is created in a communal or group situation. Someone contributes an idea about the Miró, and someone else responds to it. A third person sees something similar happening in the Kandinsky. A fourth person says, wait a minute, I don't understand. The third person tries to explain in different words, and the fourth person decides she disagrees, and so on, and so on.

Such discussions are occurring with increasing frequency on college campuses. And they are not limited to the campus itself. Today, many publishers are creating Web sites for their textbooks, and included in these sites are discussion environments where students from around the country can engage one another on issues raised by the text. Outside these formally organized environments, there are discussion groups—Listservs, or lists—focusing on almost every imaginable topic (one directory of e-mail lists is LISZT at **liszt.com**), including many art history related groups. In addition, instructors are increasingly requiring students to participate in local e-mail discussion groups. These are generally designed to serve two purposes: first, they provide the student with an opportunity to write on a routine basis; and second, they provide a forum in which students can share information and debate issues. Instructors often oversee these groups, both to monitor your progress as a writer (and thinker) and to get a sense of what their class is thinking about.

Many students find the e-mail environment to be liberating. Where they are loathe to speak up in class, they feel more comfortable behind the screen of their computer. There are no time constraints, no pressure. They can think about what they want to say, and say exactly what they mean. Furthermore, e-mail is probably the least formal of the writing media. E-mail communication is not exactly talking, but it often seems far closer to talking than to writing. It is perhaps best thought of as written conversation. As a result, most e-mail writing is relatively short. No one enjoys scrolling down a long e-mail message anymore than they enjoy listening to someone dominate a class discussion.

What kinds of discussion and writing are appropriate for e-mail? Most students find that the most common form of communication is of the question and answer format. If you are researching a particular topic, you might briefly describe what you are doing and ask if anyone has found any interesting related sources (or who checked out a particular book from the library, and can you see it too). But don't ask a question that you could answer yourself with a little effort. Don't ask if anyone knows Miró's birthdate, or the size of the Kandinsky canvas. But you can test an argument: "I'm beginning to see a woman with two large

breasts dancing in the lower right of the Miró painting. One of his rhythmic persons perhaps? Does anyone else agree?" Or something along these lines: "I'm wondering, does anyone else see the connection between abstraction and the life force in these paintings? Is that what abstraction is about?" If you think of your discussion group as a soundingboard, and if you treat the others with the same respect that you think you deserve, the group can function as if it were an on-line seminar, going on all the time outside the classroom.

There are a number of pitfalls that need you need to be aware of if you are writing in an e-mail environment. First, there is no such thing as privacy. Once you post a message in an e-mail environment, it is there for the world to see. Related to this is the question of intellectual property. While in an ideal world everyone would give you the credit you deserve for your ideas, not everyone will. If you put forth an idea in an e-mail environment, expect to see someone else use it, and without acknowledging you. A third problem is stylistic. Though this will probably change, e-mail currently has no mechanism to indicate italics, bold, accent marks, even dashes. When you cite e-mail sources in your own work, you need to be careful to add these back in—you will need to italicize titles, for instance. Fourth, we are not all equally proficient as writers. This means that we need to respect the efforts of those less able than ourselves, and it also means that not everyone is able to communicate exactly what they mean. Don't hurry to take offense in an on-line environment. Be patient. Finally, remember that electronic conversations have a kind of permanence that real-time conversations lack. You go on record on e-mail—messages are generally archived for long periods of time, even if they disappear off your screen. If you say something you should not, you may regret it. Be careful about what you say in e-mail, and be careful of the way you say it.

CREATING A FINISHED ESSAY

Organizing a Comparative Essay

Amy Harrison's essay on Miró and Kandinsky is already beginning to take shape formally in the prewriting stage, and a lot can be learned about how to organize a comparative essay simply by looking at the structure of what she has already done. Organizing a comparative essay is, for many students, an extremely vexing problem. You've got a

list of similarities, and a list of differences. You can explain why the similar things interest both artists, and you can account for their differences as well. But how do you put all this together?

You have two choices. The first is the way that most of us are taught to write a comparative essay:

 I. General Introduction of the two works (X & Y)
 II. First point of comparison (e.g., subject matter)
 A. Similarities between X & Y
 B. Differences between X & Y

 III. Second point of comparison (e.g., space)
 A. Similarities between X & Y
 B. Differences between X & Y and so on.

The problem with this approach is that it's like watching tennis: Back and forth you go, left and right, X & Y. I don't recommend it.

I recommend that you begin by stating, in general terms, what it is that the comparison between X & Y reveals. I can imagine, for instance, comparing the Spanish artist Francisco Goya's portrait of the *Countess of Chinchón* (Fig. 29) to the French painter Jacques Louis David's portrait of *Madame Trudaine* (Fig. 30). I might begin something like this: "Working at essentially the same time, under the shadow of the French Revolution and the social chaos it instigated, David and Goya arrived at radically different styles. But both responded, in their individual ways, to the turmoil and confusion of their age." Then I would do an analysis of one of the paintings—"David attempts to control his world, imposing linear order upon it," etc. Finishing that analysis, I would consider the second artist. "The order David achieves is abandoned by Goya," the second half of the essay begins. But throughout the second half, I would keep referring back to my analysis of the David. "Whereas David subjects his world to a rigid grid that controls space, Goya buries all his world in an atmosphere of shade and darkness that causes us to lose our bearings and become lost in his space." My conclusion to this imaginary essay would begin: "It is as if Goya reveals what is buried in David, opens his imagination to the terror and doubt that David controls with mathematical precision. But both recognize the terrible insecurity of the times. Goya is willing to admit his compassionate feeling for his sitter, while David inspires his to discover her own strength and courage."

Remember one important thing when writing a comparative essay: The object is not to list the similarities and differences between two works but, rather, to reveal, through the comparison, important features and traits of either or both works that would otherwise be lost or obscure.

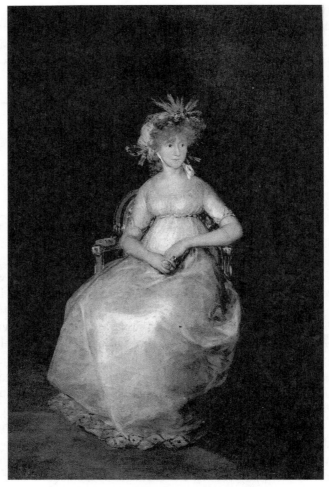

Figure 29 Francisco Goya, *Countess of Chinchón,* 1800. Oil
on canvas, 85 × 56 ¾ in. Duque de Sueca Collection, Madrid.

More to the point, the comparison must have a point. Your essay must
have a thesis.

Developing a Thesis

A formal analysis of a work of art can be distinguished from its
formal description by virtue of the fact that it takes into account the
meaning of the formal elements it describes. It asks not only *what* the

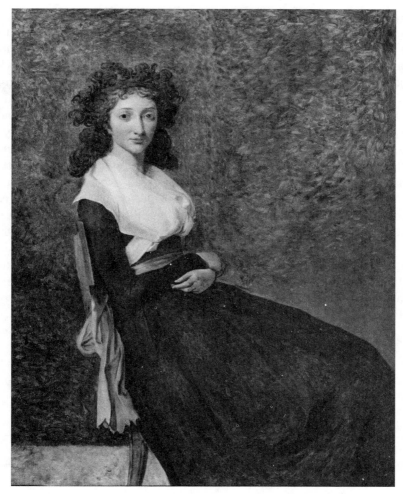

Figure 30 Jacques Louis David, *Madame Charles Louis Trudaine, born Micault de Courbetan* (1769-1802), sometimes known as *Madame Chalgrin,* 1791. Oil on canvas, 4 ft. 3 ¼ in. × 3 ft. 2 ½ in. Musée du Louvre, Paris. Giraudon/Art Resource, New York.

artists have accomplished in formal terms but *why* they have made the decisions they have. In other words, the function of the preliminary writing exercises suggested above is to help you discover ideas about the significance of the subject matter (the particular work of works of art) you have chosen to write about. They are designed to help you discover a *thesis.* For instance, Pollock's *Full Fathom Five* might be your subject matter, but your thesis consists of the central idea or point you

wish to make about the painting. If you were to write a short paper on *Full Fathom Five,* you might state your thesis in terms such as this: "While, at first glance, Pollock's painting seems to be little more than a random web of lines representing nothing, it can be approached more productively as an investigation of the possibilities of representation itself." Such a thesis statement marks the difference between the kind of writing samples presented so far and the next example, which was built out of the prewriting exercise comparing Kandinsky and Miró. Early in this text I said that all art involves conscious decisions, and I suggested that one way for you to recognize these decisions is to imagine other possible handlings of the particular work you are examining. Good comparative essays offer the most appropriate format in which you can recognize this kind of difference, which is after all a difference in intention and meaning. The real point of Amy Harrison's final essay—her thesis—is that although Kandinsky and Miró have initiated their paintings from what appears to be similar positions, they have made formal decisions that make for very different effects and that seem, in the end, to have very different meanings. The final draft of her essay concludes as follows:

> Miró portrays organic, amoeba-like shapes which create a biomorphic design. His "personnages" seem to be alive. They seem to move in a rhythmic dance through the space of his canvas. Kandinsky's design is more intricate. Rather than creating a harmonious movement through space, his shapes—on the one hand, organic, and on the other, geometric—seem at odds with each other. The geometric shapes *invade* the organic shapes, as if to hold them back and keep them from attaining their freedom: squares surround jellyfish, the orange bar pins down the cilia of the large amoeba, the smaller orange bar penetrates the little dark form, the frame contains them all like a prison. Each shape seems complete, filled, and outlined.
>
> For Miró, abstraction is a fluid *process*. It is a kind of movement, a rhythm and flow through space. For Kandinsky, this movement, this energy, as his title indicates, is *tempered*. The open flow of his forms is held in check by the geometry of the composition. Abstraction finally is a composed,

contained, and stabilized space rather than a
living and ever-changing kind of activity.
Kandinsky returns in his painting to a primitive
world that he wants to capture, while Miró
discovers a primitive world that is just beginning,
and that he is just beginning to explore.

Harrison's essay is a good one, and it met the demands of the particular assignment perfectly (the students had been asked to explore, through an analysis of two or three paintings, some of the ways in which abstraction might convey meaning). You can also see, from the previous discussion of Pollock's abstract compositions, that many of her arguments fit nicely into a larger frame. She has identified, in fact, one of the major issues of abstract art: Is it a self-contained whole, "pure painting," or is it a kind of ongoing process, an open form? It would not be very difficult to convert Harrison's essay into a discussion of the possibilities of abstract painting in the twentieth century. To do so, however briefly, would add to its richness.

Harrison needed to ask herself not only *what* these paintings mean in and of themselves—a question she has answered very well—but *how* their meaning fits into the larger context of art history. How do they reflect the age in which they were created? She need not read widely in the theory of abstract art in the twentieth century in order to develop her essay fully—although it wouldn't hurt—but she needs only to reflect a little on some of the things that she had undoubtedly heard in class and read in her text about Miró and Kandinsky—for instance, Miró's ties to the Surrealists, or some of Kandinsky's writings, such as the little book *Concerning the Spiritual in Art,* which he had written in the first decade of the century in Germany, or Kandinsky's experience with the Russian Constructivists after the Revolution and his work at the Bauhaus in Germany in the 1920s. These are all contexts that inform the paintings and that would broaden the significance of Harrison's discussion. I am suggesting that Harrison's essay could usefully undergo another *revision.*

Revising and Editing

One of the great advantages of employing any of the ways to discover ideas for writing suggested in this chapter is that they will get you in the habit of writing multiple drafts of a paper. As you move from the prewriting stage to a more formal version of your argument, you will see your ideas develop and change. You will write an even better paper,

however, if you set aside your first draft of the final version and return to it later intent on revising your thinking once again. If you have the time, it is generally worth your while to revise your essay several times.

Revision demands that you be self-critical. It is different from editing, which is the last stage of the writing process. When you edit your final draft, you check for spelling mistakes, typos, proper punctuation, and so on. (Be sure, for instance, that names of works of art are italicized or underlined.) Do not rely on a simple spell-check program provided in your software. A spell check will miss "there" when you mean "their," or "from" when you mean "form." Neither do I recommend following the advice that your software will give you under its grammar-check program. None I have yet encountered is trustworthy. Most software Thesauruses are likewise untrustworthy. The simple fact is, no software yet can read your writing in context, and therefore it cannot make proper decisions about your writing.

Do not edit on-line. The screen literally blinds you to errors. During revision, read the paper out loud. Doing this slows down the reading process, requires you to pay more attention than you otherwise might, and often reveals awkwardnesses that you can ignore when reading silently. It also allows you to "hear" whether your ideas hold together. You need to recognize at what point your argument is weaker than it should be, where you fail to state your case as strongly as you might, when you've chosen a word that is too general or too vague. Also you need to take time to make the correction. The following set of questions is particularly appropriate for writing about art:

A Revision Checklist

The Essay as a Whole

1. Have you clearly stated and developed your thesis?
2. Have you focused on particular works of art in order to support your thesis?
3. Have you discussed these works of art in sufficient detail?
4. Have you adequately considered the significance or meaning of the works, as opposed to merely describing them?
5. Have you satisfactorily accounted for the title(s) of the work(s) of art you are discussing?
6. Have you considered how these works reflect larger art historical issues and tendencies?
7. Is your argument logical? Does it make sense?

Paragraphs

1. Does your introduction clearly state your thesis?
2. Are connections between paragraphs clear? Does one follow logically from the other?
3. Does your conclusion provide a satisfying sense of completion?
4. Are your paragraphs well developed? Does each contain concrete, specific examples in support of a general idea? Are these examples interesting and persuasive?
5. Have you quoted primary and secondary sources effectively?
6. Does quoted material further your own argument?
7. Have you avoided relying too heavily on outside sources?
8. Have you avoided concluding your paragraphs with quotations? (If not, this is a good indication that you are relying on others and not developing an argument of your own.)

Sentences and Words

1. Are facts, figures, and dates accurate?
2. Are footnotes accurate?
3. Have you footnoted all the material and ideas that you found in primary and secondary sources?
4. Are there consistently no more than two or three footnotes per typed page? (If there are more, this is another indication that you are relying too much on the thinking of others and not enough on your own ideas.)
5. Have you used exact words? Is your vocabulary describing formal elements, principles of design, and media and materials accurate?
6. Is your language concrete and specific rather than general and vague?
7. Is your choice of words properly formal? (You probably want to avoid slang and jargon.)
8. Have you avoided sexist language?
9. Have you avoided clichés?

A word of warning: You will be tempted to answer "yes" to all of these questions when you really mean "more or less." Don't let yourself get away with this. Not until you can answer "yes" in all honesty—when, that is, you are being honestly self-critical—will your paper finally be ready to hand in.

WRITING ABOUT ART:
THE FINAL PRODUCT

The following essay, by Sharon Lautenschlager, another student in a nineteenth-century painting survey, expands upon its discussion of a particular painting—David's *Portrait of Madame Trudaine* (Fig. 30)—just enough to make it resonate not only with David's other work of the period, but with the circumstances surrounding the French Revolution as a whole. The painting becomes as much a portrait of the Revolution itself as of a particular French woman. In fact, an interesting problem was encountered in the course of researching this paper in preparation for publication here: The painting is referred to in the scholarship sometimes as a portrait of *Madame Trudaine,* but more often as a portrait of one *Madame Chalgrin.* According to the Louvre, however, the painting is now believed to be a portrait of Madame Charles Louis Trudaine, born Micault de Courbeton, who was born in 1769 and who died in 1802. The only way I can account for this discrepancy is to suggest that, in the confusion of the Revolution, even the identity of David's sitter was lost for a time. Lautenschlager's essay seems to capture this spirit of contradiction and discrepancy. No great amount of learning was required for her to write it, and yet the paper seems convincing, even learned. It is an example of words and images coming together in a way that enriches them both. This is admittedly a very good paper. It has, furthermore, undergone several revisions, the last with considerable input from me in preparation for publication here, so that I could provide you, in the end, with a "model" essay. But it remains, by and large, Lautenschlager's work, and it represents an example of writing about art that is not, I submit, beyond your reach.

Painting the Revolution:
David's *Portrait of Madame Trudaine*

Sharon Lautenschlager

The opening paragraph of Dickens's *Tale of Two Cities* ("It was the best of times; it was the worst of times") speaks eloquently of the essential contradictions and conflicts of the French Revolution. The *Portrait of Madame Trudaine,* painted by Jacques Louis David in 1790-91, speaks as eloquently in visual terms of

these same conflicts. This portrait is at the same time rigidly geometric and wildly passionate; it simultaneously pulls you in and pushes back at you; it is both coldly mathematical and warmly human. The composition is almost aggressively simple, and yet every element has been carefully contrived to create a specific kind of effect. Anita Brookner has said in her study of David that "David did not influence the Revolution; the Revolution influenced David."[1] His *Portrait of Madame Trudaine* bears witness to that influence.

Everything in this picture argues against something else; but everything in the picture also repeats and confirms something else. The disturbing, unsettling impact is first created by two devices, and close examination reveals multitudes of other devices that serve to maintain and enhance the original impact. One of the major "contradictions" is the color. David has painted this portrait with two sets of nearly complementary colors—dark orange and green for the larger color masses, and less intense blue and yellow for the two smaller areas. These two pairs of opposites, plus white, comprise the total palette of the picture. The second, equally important contradiction is the contrast between the absolute stillness of the sitter's posture and expression, and the wild freedom of the brushstroke throughout most of the picture, a quality that cannot be dismissed as merely a function of the painting's possibly "unfinished" state since this same brushwork appears throughout David's work in technically "finished" paintings.[2]

The painting can be broken up into almost endless geometric balances and repetitions, parallels and perpendiculars, diagonals that divide, angles that repeat one another, and ovals and curves that appear over and over again. For example, diagonals drawn from each upper corner to each opposing lower corner would intersect at the hands, which are thus precisely centered top-to-bottom and side-to-side. The right half of the

painting consists of two shapes, the background and the skirt of the sitter's dress, both of which are painted without dimension or detail, and both of which echo each other's shape. Another pair of shapes, on the left side of the painting, echo each other exactly in shape and dimension, but oppose one another in color and direction—these are the small yellow rectangle of the floor and the large orange rectangle formed by a subtle but unmistakable value shift in the otherwise random "scumbling" of the background, which makes a vertical line running from the top of the canvas to the sitter's hands. This barely perceptible line runs parallel to the sides of the frame, as does another implied line, formed by the sitter's nose, chin, the shadow line on the throat, the elbow, the sash, and finally the leg of the chair. The sash of the woman's dress has been strategically arranged to break up what would have been the curve of the back of the chair—a curve that could not have worked in the composition. A graceful or seductive tilt to the head would have been equally out of place here, so Madame Trudaine holds herself rigidly erect, with her face turned at an uncomfortably sharp angle to the body, with the eyes and mouth on a plane exactly parallel to the top and bottom of the frame, as well as the floor line. What cannot be made horizontal or vertical in the composition are curves in the face and hands, but these are made to repeat themselves. The oval of the face is the same oval as the left hand, and the same again as the eyes. The sharp curve of the end of the nose is the same curve as the end of the chin, and this angle is repeated in the crook of the arm and the end of the sash. The triangle between the chair leg and dress is repeated by shapes on the torso. This playing with line and shape could go on indefinitely.

Opposing this rigidly ordered geometry is the human element of the portrait. There is a very appealing frankness and openness in the expression

of Madame Trudaine which is confirmed by the graceful curve of the visible hand and the enigmatic smile. While the unkempt hair and utter simplicity of the dress indicate a disarming absence of personal vanity, the sharply contrasted but modestly formed bodice indicates a gentle femininity that is very appealing. Balancing and opposing this warmth, however, is the rigidly upright and tightly self-contained pose that utterly denies any invitation to intimacy expressed in the face. Beyond the pose, the composition conspires to push the figure out aggressively at the viewer by the absence of any perspectival depth. Not only has architectural detail been eliminated (no corners, window, shadows of any kind), but even the cropping, which eliminates any visible contact between the chair and sitter with the floor, prohibits orientation of Madame Trudaine in a logical space. With nothing but a geometric grid to hold her in place, the aggressive color of the background pushes her forward. While the woman's facial expression is warm and open, her body language is rigid and self-contained. While the composition is all order and simplicity, the brushwork and color are all freedom and extravagance. The effect is one of extreme tension, or of passion restrained.

David produced this painting during the first years of the Revolution, a year after *Brutus and the Lictors,* and two years before *Marat.* At the same time as this was painted, he was struggling to finish *The Tennis Court Oath.* In his monograph on David, Antoine Schnapper informs us that in the Versailles sketchbook David has scrawled a note to himself noting that the Trudaine brothers had subscribed for two prints each of the engraving of *The Tennis Court Oath.*[3] The younger brother, Charles Michel, had commissioned *The Death of Socrates,* and the elder, Charles Louis, had just commissioned David's portrait of his wife. The brothers were among David's most devoted and interested patrons, and discussions with the two

and their circle of friends had evidently been profoundly influential upon David's conception of not only *The Death of Socrates* but also *The Oath of the Horatii*.[4] Nevertheless, as so often happened, on the eve of the 9th Thermidor, in July 1794, the two brothers were both guillotined.

The *Portrait of Madame Trudaine* is an intensely emotional painting, deeply involved in the passionate struggle to create a new order of things and yet deeply conscious of the need to submit these passions to order and discipline. Her costume, as Norman Bryson has put it, "is stridently republican. . . . Her strained impassive expression and the resignation of her folded arms indicate acceptance of the changing times; it is almost the attitude of a person under arrest, a person awaiting sentence."[5] Like *The Tennis Court Oath,* the *Portrait of Madame Trudaine* is a painting literally undone by history. If not actually left unfinished by its subject's—and society's—fall from grace, then it is painted so as to feel unfinished, undone, the emblem of change itself.

NOTES

1. Anita Brookner, *Jacques-Louis David* (New York: Harper & Row, 1980), 82.

2. Jean Clay, in his *Romanticism* (New York: Vendome Press, 1981), 121, notes the similarity of this painting to David's *Portrait of Monsieur de Joubert,* painted five years earlier, in 1786. I have relied on the illustration in Clay's book for my discussion of the painting's color.

3. Antoine Schnapper, *David,* trans. Helga Harrison (New York: Alpine Fine Arts, 1980), 129.

4. Brookner, 83.

5. Norman Bryson, *Tradition and Desire: From David to Delacroix* (Cambridge, England: Cambridge University Press, 1984), 161.

APPENDIX
A SHORT GUIDE TO USAGE AND STYLE

The Rules and Principles Most Often Violated in Writing about Art

1. Possessive Apostrophes The possessive apostrophe is one of the most misused—and neglected—of all the elements of usage. Indicate the possessive singular of all nouns by adding an *'s*, no matter with what letter the noun ends:

INCORRECT	CORRECT
the artists work	the artist's work
Wyndham Lewis' drawings	Wyndham Lewis's drawings
Juan Gris' painting	Juan Gris's painting

The possessive pronouns—*hers, yours, ours, its,* and *theirs*—do not employ the apostrophe. This is especially confusing in regard to *its. It's* is the contraction of "it is."

INCORRECT	CORRECT
Consider it's form.	Consider its form.
Its important to think about form.	It's important to think about form.

Indicate the possessive plural of all nouns ending in *s* by placing an apostrophe after the concluding *s*. Plural nouns ending in letters other than *s*—such as women and media—employ an *'s*.

INCORRECT	CORRECT
the artists club	the artists' club
the missionaries purpose	the missionaries' purpose
the womens' building	the women's building

2. Commas Outlined below are several rules governing comma usage that should be followed in most situations. Commas are frequently overused, and almost as frequently, underutilized. If a comma seems to interfere with reading ease—that is, if it seems to draw attention to itself—consider eliminating it. Often, commas may be eliminated simply by rewriting your sentence.

ACCEPTABLE	BETTER
Mondrian, in the painting, employs three colors.	Mondrian employs three colors in the painting.

If, by failing to employ a comma, you create ambiguity, insert one.

WHAT WAS WRITTEN	WHAT WAS MEANT
Frequently painted images are confusing.	Frequently, painted images are confusing.

For a series of three or more terms, use a comma after each term except the last. Do not use a comma to introduce the series.

INCORRECT	CORRECT
Picasso used oil, pencil and charcoal in the painting.	Picasso used oil, pencil, and charcoal in the painting.
The sculptor had a taste for, steel, iron, and concrete.	The sculptor had a taste for steel, iron, and concrete.

Parenthetical phrases are generally set off by a comma. Place a comma both before and after the parenthetical phrase. If the parenthetical phrase is long and complex, it is often better to use alternative punctuation, such as dashes or parentheses, in order to avoid confusion (see section 11 below).

INCORRECT	CORRECT
The photograph it is important to realize depicts the scene of a crime.	The photograph, it is important to realize, depicts the scene of a crime.
Goya's etchings which were not published until long after his death are terrifying indictments of war.	Goya's etchings, which were not published until long after his death, are terrifying indictments of war.
The owner of the painting the Marquis of Toledo, neglected it for years.	The owner of the painting, the Marquis of Toledo, neglected it for years.

Before a conjunction that connects one independent clause to another, place a comma. To recognize two independent clauses, consider if the

subject of the second clause is different from the subject of the first. If the subject changes, employ a comma. Remember: A switch from a noun to a pronoun represents a change in subject.

INCORRECT	CORRECT
Georgia O'Keeffe loved the Southwest and the region deeply influenced her work.	Georgia O'Keeffe loved the Southwest, and the region deeply influenced her work.
Georgia O'Keeffe loved the Southwest and she painted it often.	Georgia O'Keeffe loved the Southwest, and she painted it often.
O'Keeffe wandered continually through the New Mexico hills, and painted them often.	O'Keeffe wandered continually through the New Mexico hills and painted them often.

3. Comma Splices Do not join together two independent clauses by means of a comma. Add a conjunction, create two separate sentences, or employ a semicolon. Use of the semicolon emphasizes the close connection between the two independent clauses (see section 11 below).

INCORRECT	CORRECT
Georgia O'Keeffe loved the Southwest, the region deeply influenced her work.	Georgia O'Keeffe loved the Southwest, and the region deeply influenced her work.
	or, Georgia O'Keeffe loved the Southwest. The region deeply influenced her work.
	or, Georgia O'Keeffe loved the Southwest; the region deeply influenced her work.

4. Run-on Sentences Do not join together two complete sentences as if they were one.

INCORRECT	CORRECT
The audience did not appreciate the painting they were blind to its beauty.	The audience did not appreciate the painting. They were blind to its beauty.

5. *That* and *Which* These two pronouns are consistently misused, the latter appearing where the former should. In contemporary spoken usage, *which* seems to be supplanting *that,* and it sometimes can be difficult to follow the "rule" and use *that* when *which* sounds better. Nevertheless, the "rule" is a simple one: *that* introduces restrictive clauses, *which* nonrestrictive clauses. A restrictive clause is one that limits or

defines its reference. A nonrestrictive clause, on the other hand, is parenthetical. Thus, if you sense that commas should be employed in your sentence, *which* in this sentence is precisely the case, use *which*. But if you sense that the addition of a comma would disrupt the flow *that* your sentence demands, use *that* and no commas.

INCORRECT	CORRECT
This is the painting which Leonardo painted in 1506.	This is the painting that Leonardo painted in 1506.

6. Titles Titles of works of art, books, and journals are italicized. Titles of short works, such as individual poems and journal articles, are put in quotation marks. If available on your word processor, use italics. If you handwrite, on an exam for instance, or type, indicate italics by underlining the title (a single underline is the editorial mark used to signify italics). Also note below that the title of Frida Kahlo's painting *The Two Fridas* is shortened, after the possessive, to Kahlo's *Two Fridas.*

INCORRECT	CORRECT
Michelangelo's David	Michelangelo's *David* (word-processed)or, Michelangelo's <u>David</u> (handwritten or typed)
John Richardson's biography, A Life of Picasso	John Richardson's biography, *A Life of Picasso* (or, <u>A Life of Picasso</u>)
The article, Kahlo's Two Fridas, appeared in Art in America.	The article, "Kahlo's *Two Fridas,*" appeared in *Art in America.* (Or, The article, "Kahlo's <u>Two Fridas</u>," appeared in <u>Art in America</u>.)

7. Foreign Phrases While you might prefer to avoid foreign phrases in general writing, you cannot in writing about art, because a good deal of specialized vocabulary based on foreign words has developed to describe various artistic effects. Italicize (or underline) such foreign phrases. Notice in the third example below that, without italics, the meaning of the phrase is confusing.

INCORRECT	CORRECT
Magritte's trompe l'oeil paintings look real	Magritte's *trompe l'oeil* paintings look real
The painting's haziness derives from sfumato.	The painting's haziness derives from *sfumato.*
By means of passage, Cézanne blends different planes together.	By means of *passage,* Cézanne blends different planes together.

8. Split Infinitives Generally, do not place an adverb in the middle of an infinitive construction. Occasionally, however, especially in less formal writing, to do otherwise will sound overly formal, even awkward, and will disrupt the flow of your writing. In such instances, splitting the infinitive is at least acceptable— and probably preferable.

INCORRECT

He wanted to systematically print the edition.

CORRECT

He wanted to print the edition systematically.

ACCEPTABLE

He could never really learn to appreciate abstract art.

ALSO ACCEPTABLE

He could never learn to really appreciate abstract art.

9. Sentence Fragments Make sure that each of your sentences contains a subject and a verb. Make sure you do not mistake a verb form ending with *-ing* (a participle) for a verb. Make sure you have not used a period when a comma is the proper punctuation.

INCORRECT

The sculpture of the horse balances on one leg. A perfect example of the Han dynasty's mastery of bronze casting.
The drapery falls in deep folds and hollows. Contributing to the sense of reality in the work.

CORRECT

The sculpture of the horse balances on one leg, a perfect example of the Handynasty's mastery of bronze casting.
The drapery falls in deep folds and hollows, contributing to the sense of reality in the work.

10. Colons Use the colon to introduce lists, or other amplification, and quotations (for quotations, see section 14 below). When the introductory material is a complete sentence, use a colon after it. However, when the introductory material is not a complete sentence, use no punctuation. Do not use the colon after a verb, as in the second and third incorrect examples below.

INCORRECT

A good caption should include these six things, the name of the artist, the title of the work, the date of execution, the work's medium, its dimensions, and its present location.
A good caption should also include: the name of the artist, the title, etc.
Picasso's point is: War is hell.

CORRECT

A good caption should include these six things: the name of the artist, the title of the work, the date of execution, the work's medium, its dimensions, and its present location.

Picasso's point is simple: War is hell.

11. Semicolons Use the semicolon in lists the parts of which are relatively long or complicated and to coordinate parallel ideas expressed in independent clauses. To avoid confusion, use semicolons to separate elements of a list when those elements themselves contain commas.

INCORRECT	CORRECT
He saw three things: first, the painting's line, which was expressive, second, its color, which was als expressive, and finally, its overall design, which was curiously classical.	He saw three things: first, the painting's line, which was expressive; second, its color, which was also expressive; and finally, its overall design, which was curiously classical.

The semi-colon is also useful as a coordinating conjunction—that is, as a way to join parallel constructions. Think of the semicolon as the fulcrum of a pair of perfectly balanced independent clauses, and you will use it to great effect. Indeed, its use is often most appropriate in contexts that imply balance of one kind or another, when, for instance, in two independent clauses we find *early* in the first and *later* in the second, or *on the one hand* in the first and *on the other hand* in the second, sometimes and at other times.

ACCEPTABLE	BETTER
On the one hand, Goya was dependent upon the monarchy. On the other hand, he appears to have despised it.	On the one hand, Goya was dependent upon the monarchy; on the other, he appears to have despised it.
Early in his career, the photographer concentrated on rendering light. He later transformed this interest by using light as a means to reveal form.	Early in his career, the photographer concentrated solely on rendering light; later, he rendered light in order to reveal form.

12. Dashes Use dashes to set off a parenthetical phrase that itself contains punctuation, especially commas; use the dash to introduce a phrase that repeats and emphasizes elements you have already used in a sentence; and use it to introduce constructions beginning with *that is, namely, i.e.,* and so on. There is no space on either side of a dash. On word processors, the proper dash to employ is the so-called em-dash (a typographer's term). Since it is usually a special character, check your software manual for its keyboard location. On a typewriter, the em-dash is indicated by typing two consecutive hyphens-- as we have shown here--again leaving no space on either side of the hyphens.

ACCEPTABLE	BETTER
The dealer sensed the situation, that, for whatever reason, his client was not pleased, unhappy perhaps with the painter's manner, and so he hastened to facilitate their departure.	The dealer sensed the situation—that, for whatever reason, his client was not pleased, unhappy perhaps with the painter's manner—and so he hastened to facilitate their departure.
The painting was subdued, yet daring, subdued in its color, but daring in its scale.	The painting was subdued, yet daring— subdued in its color, but daring in its scale.
He taught painting as a profession, that is, as a way of life.	He taught painting as a profession—that is, as a way of life.

13. Parentheses The first example above could as easily be punctuated with parentheses as dashes: "The dealer sensed the situation (that, for whatever reason, his client was not pleased, unhappy perhaps with the painter's manner), and so he hastened to facilitate their departure." Notice that there is no punctuation before the parentheses (never, under any circumstances, place a comma before parentheses), though a comma is necessary after the parenthetical expression. (An entire sentence, or several sentences, can also be placed in parentheses. When you do this, the final punctuation, a period or question mark, goes inside the final parenthesis.)

14. Quotations Generally, introduce any quotation that is a complete sentence or longer with a colon and enclose it in quotation marks. All punctuation falls within the quotation marks.

INCORRECT

In his 1886 novel, *The Masterpiece,* Emile Zola provides a fictionalized account of how Impressionist painting was initially received, "It was one long-drawn-out explosion of laughter, rising in intensity to hysteria. As soon as they reached the doorway, he saw visitors' faces expand with anticipated mirth".

In the example above, the quotation should be introduced with a colon and the final period should be inside the quotation marks:

CORRECT

In his 1886 novel, *The Masterpiece,* Emile Zola provides a fictionalized account of how Impressionist painting was initially received: "It was one long-drawn-out explosion of laughter, rising in intensity to hysteria. As soon as they reached the doorway, he saw visitors' faces expand with anticipated mirth."

Quotations shorter than a sentence are enclosed in quotation marks, but are subject to your own punctuation. The above example might be shortened, for instance, by writing it as follows.

CORRECT

In his 1886 novel, *The Masterpiece,* Emile Zola describes the "long-drawn-out explosion of laughter" that greeted Impressionist painting—a "mirth" that rose eventually, he says, to "hysteria."

Notice, incidentally, that even though only a single word is quoted at the sentence's end, the period still goes inside the quotation marks. If you turn to page 15 of this book, you will notice that the actual passage quoted from Zola's novel is much longer. If your quotation is longer than forty words, or approximately 4 lines, or if its lineation is important, as in poetry or a play, differentiate the quotation from the text proper by beginning on a new line and indenting the entire quotation five spaces. Such typographical indentation is a sign of quotation, *and so do not also use quotation marks.*

15. Ellipses Both the quotations on pages 14 and 15 also make use of ellipses, or "dots" that indicate that material has been omitted from the original text. An ellipsis consists of three "dots," with a space before, after, and between each dot. When you are eliminating material from the middle of a sentence, use these three dots. When you eliminate a whole sentence or more, conclude the sentence before the ellipsis with a period, and then type the ellipsis as you normally would.

ORIGINAL QUOTATION

The outside world must not come in, so windows are usually sealed off. Walls are painted white. The wooden floor is polished so that you click along clinically or carpeted so that you pad soundlessly, resting the feet while the eyes have at the wall. The art is free, as the saying used to go, "to take on its own life."

BRIEF OF PART OF ONE SENTENCE

The outside world must not come in, so windows are usually sealed off. Walls are painted white. The wooden floor is . . . carpeted so that you pad soundlessly, resting the feet while the eyes have at the wall. The art is free, as the saying used to go, "to take on its own life."

ELLIPSIS OF A SENTENCE OR MORE

The outside world must not come in. . . . The art is free, as the saying used to go, "to take on its own life."

The last example above is so short—less than forty words and fewer than four lines—that it would not, if quoted, ever be indented. It would be enclosed in quotation marks. This would result, incidentally, in a quotation within a quotation. Use single quotation marks to indicate quotations within quotations.

INCORRECT	CORRECT
"The outside world must not come in. . . . The art is free, as the saying used to go "to take on its own life.""	"The outside world must not come in. . . . The art is free, as the saying used to go, 'to take on its own life.'"

16. Dangling Modifiers Participial phrases at the beginning of sentences must refer to the subject of the sentence.

INCORRECT	CORRECT
Being depressed, the painting seemed darker than it actually was.	Because I was depressed, the painting seemed darker than it actually was.

17. Subject-Verb Agreement Make sure that your verb form is singular if the subject of your sentence is singular and plural if the subject of your sentence is plural. Do not be led astray by intervening words.

INCORRECT	CORRECT
The use of paint, turpentine, and sand serve to create a unique surface.	The use of paint, turpentine, and sand serves to create a unique surface.
The proof of the pudding—the most telltale signs of the painter's genius and the hallmarks of her personal style—are wholly absent.	The proof of the pudding—the most telltale signs of the painter's genius and the hallmarks of her personal style—is wholly absent.

If sentences such as those on the right above sound awkward to your ear, consider rewriting them:

CORRECT	BETTER
The use of paint, turpentine, and sand serves to create a unique surface.	Paint, turpentine, and sand serve to cre-ate a unique surface.
The proof of the pudding—the most telltale signs of the painter's genius and the hallmarks of her personal style—is wholly absent.	The most telltale signs of the painter'sgenius and the hallmarks of her personal style—the proof of the pudding—are wholly absent.

Remember that when *none* means "not one" or "no one," it is singular and is used with a singular verb.

INCORRECT	CORRECT
None of the paintings are finished.	None of the paintings is finished.

Remember that *each, every, either,* and *neither* also are singular and take singular verbs.

INCORRECT	CORRECT
Each of the drawings are wonderful.	Each of the drawings is wonderful.
Every one of the sculptures were done in bronze.	Every one of the sculptures was done in bronze.
Neither of the portraits resemble him.	Neither of the portraits resembles him.

18. Pronoun Agreement Make sure when you employ a plural pronoun that its referent is plural.

INCORRECT	CORRECT
Each of the paintings must be judged on their own merits.	Each of the paintings must be judged on its own merits.
Neither of the students wanted to have their work subjected to criticism.	Neither of the students wanted to have his work subjected to criticism.

19. Pronouns and Gender Issues When you employ a noun that is general in character—"the artist" or "the student," for instance—referring not to a specific artist or student but to the artist as a type or to the student body in general, pronoun reference to this antecedent is complicated by matters of gender. If I write, "The artist must always consider *his* medium," I have arbitrarily determined that the sex of "the artist" is male. Why not write, "The artist must always consider *his or her* medium"? Or, why not just, "The artist must always consider *her* medium"? Of course, choosing these last alternatives draws attention to your own awareness that there are subtle gender issues at play in our habits of usage. I recommend, however, that you avoid such constructions altogether by referring to such general types of people in the plural—by choosing for your noun "artists" instead of "the artist," or "students" instead of "the student." In this way, your prose will be gender neutral.

ACCEPTABLE	BETTER
If originality is what makes art great, then the artist must strive always to make his work original.	If originality is what makes art great, then artists must strive always to make their work original.
At this university, the student is allowed to realize his or her potential.	At this university, students are allowed to realize their potential.

20. Indefinite Antecedents When you use the words *it* and *this,* be sure that their referents are clear to the reader. Very often writers expect these words to carry the complete sense of the sentence, or even paragraph, just completed. Generally, when you write the word *this* at the beginning of a sentence, always follow it with a noun or noun phrase—that is, do not leave its referent implied.

AMBIGUOUS

The viewer feels that there is humor in the work, but nowhere in the artist's writings, does he say anything about it. [Does *it* refer to his humor or his work?]

The Chinese landscape painter works as a calligrapher might, emphasizing line to such a degree that his subject matter seems almost secondary, and yet the landscape is itself a gesture, endowed with meaning and feeling. This underscores the importance of calligraphy in Chinese art. [What does *this* refer to? The previous sentence, or a smaller fragment of it?]

CLEARER

The viewer feels that there is humor in the work, but nowhere in the artist's writings, does he say anything about the painting.

The Chinese landscape painter works as a calligrapher might, emphasizing line to such a degree that his subject matter seems almost secondary, and yet the landscape is itself a gesture, endowed with meaning and feeling. This emphasis on the gestural qualities to be found in nature itself underscores the importance of calligraphy in Chinese art.

21. Correlative Expressions Correlative expressions are phrases mutually related by terms such as *both/and,* and *not only/but also.* The phrases that follow such expressions should be parallel—that is, they should utilize the same grammatical construction.

INCORRECT

Audubon's prints are both documentary in character and they possess their own formal beauty.

Not only does he depict each specie accurately, but also each of his birds becomes an element in the design of the page.

Audubon first approached his subjects in the wild, then he shot them, and finally they were stuffed so that he could study them in detail.

CORRECT

Audubon's prints possess both a documentary character and an inherent formal beauty.

He not only depicts each specie accurately but also incorporates each bird into the design of the page.

Audubon first approached his subjects in the wild, then shot them, and finally stuffed them so that he could study each specie in detail.

Notice that to correct each of the sentences above some rewriting was required. In the third example, for instance, the parallel structure of "shot them" and "stuffed them" made it awkward to repeat "study them" in the subordinate clause. The phrase was rewritten, therefore, to read "study each specie." Also pay close attention to the position of the subject in *not only/but also* constructions. If the subject occurs before the "not only," do not repeat it in the "but also" phrase. However, if the subject occurs after the "not only," then it must also be repeated after the "but also."

INCORRECT	CORRECT
He not only paints, but he also sculpts.	He not only paints but also sculpts.
Not only has Nancy Holt worked in thedesert but in urban environments as well.	Not only has Nancy Holt worked in thedesert, but she has also created pieces in urban environments as well.

22. Verb Tense Consistency Never shift from one tense to another within a single sentence.

INCORRECT	CORRECT
Caravaggio utilizes light in this work to new ends and, in so doing, created new emotional possibilities for painting.	Caravaggio utilizes light in this work to new ends and, in so doing, creates new emotional possibilities for painting.

Remember as well that when describing works of art in longer passages of a paragraph or even a few sentences in length, it is a convention of usage to employ the present tense throughout.

23. Diction Consistency Diction is word choice, and different kinds of writing call for different levels of diction. Writing can be informal in diaries or journals, for instance. But most written assignments call for more formal language. Generally, it is inappropriate to introduce colloquial or slang expressions into such formal writing.

INAPPROPRIATE	BETTER
The formalist critic does not believe in the possibility of a work of art beinginteresting on both aesthetic and political levels. Such a point of view is total baloney.	The formalist critic does not believe in the possibility of a work of art beinginteresting on both aesthetic and political levels. Such a point of view seems to me mistaken.

24. Concrete and Specific Language Good writing depends upon the richness of the detail it brings to bear upon a given subject. In writing about art, the more concrete and specific your descriptions, the better your writing will be. In coming up with concrete detail to describe general effects, you will almost certainly come to a better understanding of the work under discussion. The example in the left column below is part of an actual student response to an essay question on van Gogh's painting *The Night Café* (Fig. 17). While there is nothing technically "wrong" with this answer, it is too vague to be interesting—or to receive a good grade. If its writer knows more, these sentences don't reveal it. It takes some effort to improve prose by

making it more concrete, but you'll like your writing better, and probably receive a higher grade.

TOO VAGUE	CONCRETE AND SPECIFIC
Van Gogh's painting is unique. His use of color is highly dramatic, as is his application of paint. They combine to create a sense of tension that pervades the composition.	Van Gogh's painting is unique in itshandling, in the way that his characteristic short and choppy brushstroke is laid against a broad, flat zone of color, a technique he usually reserved only for portraiture. The all-encompassing flatness of the red wall contrasts with the thickly painted rays of light emanating from the three lamps, with the awkward gestures that seem to sweep up the floor towards the door, and, most of all, with the deep green impasto of the billiard table. The tension created by the complementary contrast of red and green, meant by him to evoke the "terrible passions of humanity" present in the café, is thus underscored in the application of the paint itself.

25. Frequently Misspelled Words The following list is provided in order to alert you to the those words that, in writing about art, I most frequently find misspelled. You would be wise to learn these.

> **affect** . . . not effect ("Affect" is a verb meaning to "influence"; "effect," when used as a verb, means to "bring about"; as a noun, it means "result")
>
> **a lot** . . . not alot
>
> **all right** . . . not alright
>
> **chaos** . . . not kaos
>
> **color** . . . not colour (The second is the British spelling.)
>
> **column** . . . not colume
>
> **complementary color** . . . not complimentary
>
> **dimension** . . . not demension
>
> **effect** . . . not affect (See "affect" above.)
>
> **frieze** . . . not freeze
>
> **gray** . . . not grey (The second is the British spelling.)
>
> **illusion** . . . not allusion (Allusion means indirect reference.)
>
> **intaglio** . . . not intalio
>
> **light** . . . not lite
>
> **parallel** . . . not paralel

permanent . . . not permenent or permanant

referring . . . not refering

rhythm . . . not rythm

separation . . . not seperation

spatial . . . not spacial (I've had as many as 50 of 55 students misspell this one on an exam.)

subtle. . . not sutle

symbolic . . . not symbollic

symmetry . . . not symetry

through . . . not thru

twentieth-century art . . . not twentieth century art (Used as an adjective such temporal designations employ a hyphen.)

volume . . . not volumn (This word is often confused, apparently, with column.)

watercolor . . . not water color

your professor's name . . . No one notices if you spell it right, but to spell it wrong is to announce your inattention to detail.

NOTES

Introduction

1. Betty Edwards, *Drawing on the Right Side of the Brain: A Course in Enhancing Creativity and Artistic Confidence* (Los Angeles: J. P. Tarcher, 1979).

2. Francine du Plessix Gray and Cleve Gray, "Who Was Jackson Pollock?" interviews with Lee Krasner, Anthony Smith, Betty Parsons, Alfonso Ossorio, *Art in America* 55 (May-June 1967): 51.

3. H. H. Arnason, Robert Motherwell, 2nd revised ed. (New York: Abrams, 1982), 182-83.

Chapter 1

1. Pierre Bourdieu and Alain Darbel, *L'Amour de l'Art* (Paris: Editions de Minuit, 1969), appendix 4, table 8.

2. Mina Loy, "Gertrude Stein," in *The Last Lunar Baedeker,* ed. Roger L. Conover (Highlands, N.C.: The Jargon Society, 1982), 298.

3. Brian O'Doherty, "Inside the White Cube: Notes on the Gallery Space," *Artforum* 14 (March 1976): 24-25.

4. Emile Zola, *The Masterpiece,* trans. Thomas Walton (Ann Arbor: University of Michigan Press, 1968), 128-29.

5. Milton W. Brown, *American Painting: From the Armory Show to the Depression* (Princeton, N.J.: Princeton University Press, 1955), 113.

6. These arguments are more fully developed in my article, "American Vernacular: Objectivism, Precisionism, and the Aesthetics of the Machine," *Twentieth Century Literature* 35 (Fall 1989): 310-12.

7. André Malraux, *Museum Without Walls,* trans. Stuart Gilbert and Francis Price (London: Secker & Warburg, 1967), 11-12.

Chapter 2

1. Joshua Taylor, *Learning to Look: A Handbook for the Visual Arts* (Chicago: University of Chicago Press, 1957), 44, 50.

2. Ibid., 52.

3. Quoted in Irving Stone, *Dear Theo: The Autobiography of Vincent van Gogh* (New York: Doubleday, 1937), 383-84.

4. Dore Ashton, *Picasso on Art: A Selection of Views* (New York: Viking Press, 1972), 8.

5. Stone, *Dear Theo,* 383.

6. Annie Besant and C. W. Leadbeater, *Thought-Forms* (Wheaton, Ill.: The Theosophical Publishing House, 1969), 23-24.

7. Isamu Noguchi, "On Gardens as Sculpture," *A Sculptor's World,* 1968 <http://www.noguchi.org/intextall.html> (18 March 1998).

8. Isamu Noguchi, *The Isamu Noguchi Garden Museum* (New York: Abrams, 1987), 37.

9. Henri Cartier-Bresson, The World of Henri Cartier-Bresson (New York: Viking Press, 1968), 3.

10. David Antin, "Video: The Distinctive Features of the Medium," in *Video Art* (Philadelphia: Institute for Contemporary Art, 1975), 64.

11. Lynn Hershman, *Chimaera: Monographie* (Montbeliard and Belfort, France: Edition du Centre Internationale de Création Vidéo, 1992), 95-96.

Chapter 3

1. "Unframed Space," in "The Talk of the Town," *New Yorker* 26 (August 5, 1950): 16.

2. Jackson Pollock, Statement, *Possibilities* 1 (1947): unpaginated.

3. Andrea Lunsford, survey of 2500 students, reported in "When Student Writers Use the Web: Problems and Issues," a public presentation, Oregon State University, 20 Feb. 1998.

4. James Hall, *Dictionary of Subjects and Symbols in Art* (New York: Harper & Row, Icon Editions, 1974), 81, 85.

5. Henry Adams, *The Education of Henry Adams,* ed. Ernest Samuels (Boston: Riverside Editions, 1973), 380, 382.

6. Robert Wohl, "The Generation of 1914 and Modernism," in *Modernism: Challenges and Perspectives,* ed. Monique Chefdor, Ricardo Quinones, and Albert Wachtel (Urbana: University of Illinois Press, 1986), 72.

7. These positions, and others as well, can be discovered in Francis Frascina, *Pollock and After: The Critical Debate* (New York: Harper & Row, 1985).

8. Arianna Stassinopoulos Huffington, *Picasso: Creator and Destroyer* (New York: Simon and Schuster, 1988), 10.

INDEX